MINIATURE PAINTING

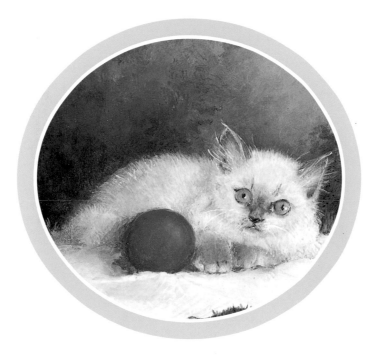

MINIATURE PAINTING

A Complete Guide to Techniques, Mediums, and Surfaces

JOAN CORNISH WILLIES
R.M.S., H.S., M.A.A.

WATSON-GUPTILL PUBLICATIONS
New York

Cover image:
STILL LIFE
Oil and alkyd on ivorine. Courtesy of Dr. M. Taqui.

Half-title image:
KITTEN
Transparent acrylics on ivorine.

Note: The illustration of *Portrait of a Nobleman* by Nicholas Hilliard, page 15, is reproduced with permission of The Metropolitan Museum of Art, New York. Copyright © 1994 by The Metropolitan Museum of Art.

The lid of the harpsichord, page 22, is reproduced with the courtesy of Mrs. Barbara Reich. The works by Jan Markut, page 23, are illustrated with the kind permission of Mrs. Krystina Markut.

First published in 1995 in the United States by Watson-Guptill Publications, a division of BPI Communications, Inc., 1515 Broadway, New York, NY 10036

Library of Congress Cataloging-in-Publication Data

Willies, Joan Cornish, 1929—
 Miniature painting : a complete guide to techniques, mediums, and
 surfaces / Joan Cornish Willies.
 p. cm.
 Includes index.
 ISBN 0-8230-2979-4
 1. Miniature painting—Technique. I. Title.
ND1330.W653 1995
751.7'7—dc20
 95-6880
 CIP

Manufactured in Singapore

2 3 4 5 / 99 98 97 96

Senior Editor: Candace Raney
Associate Editor: Dale Ramsey
Designer: Jay Anning
Production Manager: Hector Campbell

For Mark, my family, Tom, Beryl, and my cherished friend Milly

CONTENTS

FOREWORD

In the last fifteen years the interest in miniatures has grown, at first slowly, and then with ever-increasing speed and enthusiasm. Before this, a few societies in Britain, with its long tradition of miniature painting, and the United States worked quietly, and without any great attention from the public, at keeping the traditions of the exquisite art of the miniature alive and well.

Then came stirrings of new life. Younger artists discovered the joy of painting in miniature, and at the same time houses became smaller and many people moved to apartments. They had less space and regarded the miniature not only as a delightful replacement for the large family portrait but also as pictures they had the space to collect. More patrons surfaced to collect these small gems.

Everything thus combined to give new support to a venerable discipline. More clients bought, more artists painted, inspired by the demand for their pictures, and a new band of people became manifest—the would-be miniature painters. In support came teachers and authors of books for the amateur anxious to learn.

These treatises were not very long, but all were good and useful of their kind. Nevertheless, as the anxiety to be taught grew and all manner of new media became available, the need became apparent for a more detailed treatment of this fascinating and entrancing subject. Such a book you hold now in your hand. It will answer many questions that the amateur or proficient artist may wish to ask and be invaluable to anyone wanting to learn from the beginning or to others as a book of reference.

Therefore I wish this volume the success it deserves and congratulate Joan Willies on her untold hours of patient hard work. Having made the same kind of effort in publishing the Hundredth Anniversary Book for the Royal Society of Miniature Painters, Sculptors and Gravers, I know how much she has put, not only of her knowledge but also of herself, into this praiseworthy book.

SUZANNE LUCAS
P.R.M.S., F.P.S.B.A., S.W.A., H.S.F.

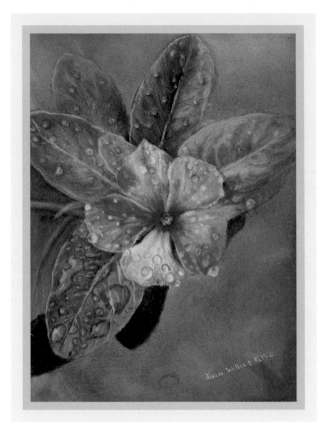

PERIWINKLE IN RAIN

Oil on ivorine

Acknowledgments

To write a book with both technical information and color illustrations, giving the painter many graded steps in painting a good miniature, has long been my ambition. Thank you, Watson-Guptill Publications, for giving me this opportunity.

I am grateful to Suzanne Lucas, P.R.M.S., F.P.S.B.A., S.W.A., H.S.F., President of the Royal Society of Miniature Painters, Sculptors and Gravers, for her gracious foreword.

This book could not have been written without the help of many people. First, a big "thank you" to Candace Raney, senior acquisitions editor of Watson-Guptill, for her faith in this project and forbearance in regard to this author's struggle with a computer, about which another book could be written! I also deeply appreciate the wonderful work of my editor, Dale Ramsey.

My gratitude extends to Clive and Lynne Beckett of C.M.C., Clearwater, Florida, who came to my rescue, and proofread, retrieved lost data, and collated my manuscripts with their highly professional ability; to Harriet Kelso, who rushed slides to the developers many times; to her husband, Glen Kelso, who patiently instructed me in the computer program required for the text; to Al Beck, who with patience answered computer questions often after hours, particularly when two bad lightning strikes fractured hours of work; and to my good friend Jo Webber, who also proofread my manuscripts.

For subject material, my thanks to Beryl and Peter Kemp, Hazel Tertsakian, Alexandra Triber, Paul Willies, and Kim Willies.

I am indebted to Anita Emmerich and Marcelle Shears of the Royal Society of Miniature Painters, Sculptors and Gravers, England. Both gave me help and historical information.

Mrs. Dietgard Bindel, Switzerland; Mr. & Mrs. Andrew Willies, Canada; June Gelbart, Florida; Miss Hayley Mills, England; Dr. M. Taqui, Maryland; Dick and Thelma Wallace, Florida; Jo Webber, Florida; and the Miniature Art Society of Florida, graciously loaned some of my paintings which they own for this book, and I thank them very much. In particular, I would like to thank Krystina Markut, wife of the late Jan Markut, who loaned some of her precious collection of photographs of her late husband's illuminations.

To Wendel Upchurch, of Winsor & Newton, special thanks for all the years of friendly technical advice, and for the "recipe" used in this book.

Thanks also to the following key people in the Manufacture of Artists Materials, who have kept me informed and supplied samples of newly developed products suitable for painting miniatures in the ancient technique, using modern materials and tools: Sally Drew of Daniel Smith; Fay Paddock of Koh-I-Noor; David Ford of Schmincke and Cosmos da Vinci; Edward Flax of the Martin Weber Company; Ross Hagstoz of Hagstoz & Son, Assayers; Deidra Silver, of Silver Brush Ltd. Many thanks also to Fulmers Photography, Clearwater, Florida.

I thank my very special group of students for their encouragement. To Leslie Hunt, George Gill, Diane Whicher, and—last but not least—to my mother and my husband, Mark, who have given me so much support, my deepest thanks.

My hope is that readers will derive pleasure and satisfaction from producing miniature paintings by trying out the exercises in this book. I would like to hear from you.

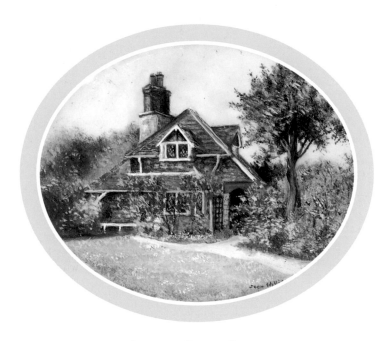

COTTAGE, BLAISE CASTLE

Oil and alkyd on ivorine

Introduction
THE ART OF
THE MINIATURE

The term *miniature* relates first of all to technique and identification and only secondly to the size of a painting. One can produce a 12-inch painting which is also a miniature. The size of a miniature is traditionally described as small enough to carry in a person's hand, pocket, or bag. But this implies that sizes can vary enormously. Presumably, as long as the miniature technique is observed, a wall could be painted in miniature, even though the preciousness of the hand-held miniature would be lost.

This technique, as we shall see, is a specialized means of producing a perfect balance of both color and detail in a series of thinly applied colors, intended to reflect light, within the boundary of a small frame. This does not mean that only traditional watercolor paint can be used. The technique produces the recognizable translucent and delicate look of the multilayered painting, but it can be applied using any of our present-day mediums.

The word *miniaturism*, sometimes heard in the United States, is not a correct description of the discipline of the miniature. "Miniature painting," or "the art of the miniature," is the correct description of this enchanting and fascinating branch of fine art.

This book proceeds in easy stages to teach the painting of miniatures of various kinds. The method is simple: to learn the full repertoire of techniques and to derive a sense of accomplishment from the process, the reader is shown how to paint the pictures that are featured in this book. The lessons cover essential miniature-painting practice. We'll cover how to handle a small brush skillfully, using several different mediums, on several different grounds. We'll begin gradually, examining almost every movement of the brush.

Unless you are already painting miniatures, it is probably better to start at the front of the book and work through to the back. If you have not painted before, you may find the technique easier than would the artist who has always made large paintings. Remember that the drawing of these very small pictures requires getting used to. Regard your original sketch work as important, because perspective and placement of features need to be accurate.

When you paint a miniature, you are continuing a discipline that was here before many others. It needs to be protected. The art of the brushwork, glazes, detail, and realism "in the little" needs the artist like yourself to enjoy its enchantments, learn it, and pass on the knowledge.

1 MINIATURE PAINTING YESTERDAY AND TODAY

Miniature painting goes back in history to those eras when there were few people who could write and documents and books were beautifully illuminated by scribes, who took great pride in the shaping of their letters. These scribes worked for the very rich, those who were members of the reigning families and their courts, and those who owned large areas of land. The skill of miniature painting was developed by painters in Japan, China, Persia, Arabia, Russia, Italy, Germany, France, Belgium, England, and other European lands.

Major religions on various continents communicated with documents and described their religious doctrines in books. Pictures were used to add to the meaning of the text and to instruct the illiterate. This practice has continued to this day (several hundreds of years were to pass before the humble people in most countries were able to become literate).

EVOLUTION

Around 900 or more years ago, the scribes were called upon to add a likeness of their employer to a page in a book he had asked to be made, or to a document of importance, where it was most important for the illiterate people to recognize him when the document was shown to them. Important statements in these books and documents were frequently underlined or outlined in red to draw attention to them.

By the time of Henry VII's reign in England, there were many monks and scribes attached to the courts and noble households to perform all the tasks relating to communications. They often had heraldic duties as well. The families of the nobility were required by the king to register the designs carried on their shields or worn on their tunics. This way, there would be no duplications, and the symbols could be recognized on the field of battle. These coats of arms were sometimes also painted within the illuminated borders decorating a book or document. These paintings were sometimes accompanied by a portrait identifying the nobleman. Frequently the likeness was painted inside a gilded initial capital letter, frequently within a loop.

The paint which bordered and underlined sections of the document and circled the portrait was called *minium*. Important capitalized words were illuminated with gold and also outlined in minium, a red paint made with lead, and thus the portrait contained within the initial capital letter came to be called a *miniature*, after the paint.

In early books, many of them done in France, there were often little pictorial scenes, and these together with the portraits which followed them were, because of their size, called *mignature*. This word gradually became associated with tiny paintings.

PORTRAITURE

Sometime during the reign of Henry VII, a portrait was cut out of a vellum book or document. Possibly it was carried as an identification by a courier, confirming that he represented the king or prince whose likeness was in the portrait. Patrons of the arts also required these likenesses to present them as a favor to foreign ambassadors, or to a prospective bride or groom in an arranged marriage.

Eventually, medalists, jewelers, and goldsmiths practiced this art, and therefore the tradition of wearing miniature portraits came about.

Illuminated borders around breviaries of the time showed skillful, realistic renderings of fruit and flower borders around *en grisaille* (three-dimensional monochrome) portraits.

The brilliant hues of the illuminations were at first used as background colors matching the colors of gems. These came to adorn portraits. A famous miniature portraitist of the 16th century, the Englishman Nicholas Hilliard, named his colors after gems, and could replicate jewels so well in trompe l'oeil that it was hard to tell which was the gem and which was the painting. His red he named ruby, his blue "saphire" (sapphire), his green "emrod" (emerald), and his yellow "topies" (topaz). The early

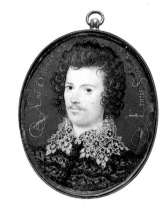

NICHOLAS HILLIARD (1547-1619): PORTRAIT OF A NOBLEMAN.
Gouache on cardboard.
1⅝" x 1⅜" The Metropolitan Museum of Art, Fletcher Fund, 1935.

The image is shown actual size at left. Below, in the detail, greatly enlarged, one can see ample evidence of the fine detail work that is the hallmark of the ancient miniature-painting tradition.

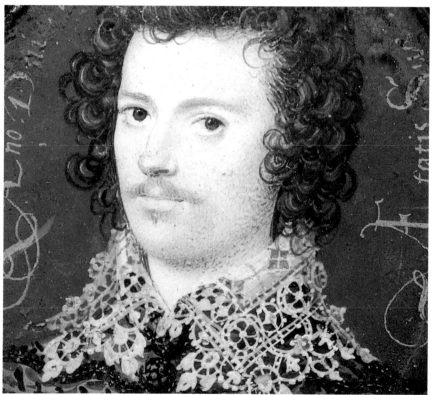

miniature palette was brighter than that of other pictures and included metallic tints made with the metals themselves. Yet the colors balanced in intensity, so that no one color stood out above the others.

Mostly they were painted in watercolors. Hilliard, in his treatise on the art, insisted that it be practiced in a tranquil atmosphere, even recommending that "ill smelling colors" not be used, that dandruff from hair not be allowed to fall, and that coughing be avoided, lest any "spettel" fall on the watercolor. Listen to soft music, keep out questioners, and refrain from anger with those who would touch the work, he said.

In Latin, the word *illuminare* means to paint. This became the French word *enluminer*, from which evolved the English word *limner*, for a person who draws and paints. In Stuart and early Hanoverian times, a limner's works, including miniatures, were popularly described as *limnings*. In the 17th century it became popular to describe the painter of a miniature as a *miniator*. All these words pertained more to the miniature's detailed and realistic technique than to its size.

Many exquisite miniature portraits were painted on ivory. In mid-17th-century India, the Shah Jahan, the ruler who built the Taj Mahal, commissioned miniature portraits that were copied and imitated numerous times over the next three centuries. The two portraits shown here, by an unknown artist, are in that tradition. They depict the sumptuously garbed Shah and his beautiful wife, Mumtaz Mahal, in extraordinary detail. The four corners of the painting of Shah Jahan are painted in a dark red gouache, over which is painted a design of flowers in gold. His short coat is underpainted in unburnished 24-karat gold, and over this in watercolor and gouache are painted tiny flowers. His gown is painted in transparent watercolor, through which the ivory can be seen. Within the archway the ivory is glazed in diluted watercolor, and another layer has

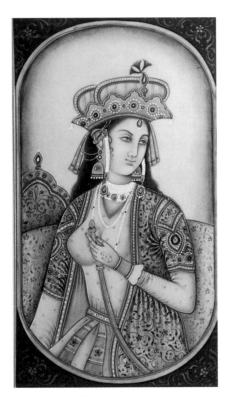

MUMTAZ MAHAL
6 x 3¼"

Watercolor and gouache on ivory, mounted on silk.

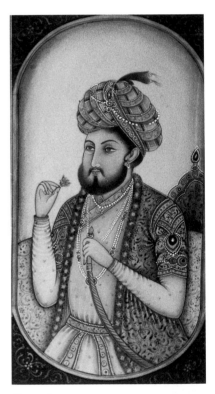

SHAH JAHAN
6 x 3¼"

Watercolor and gouache on ivory, mounted on silk.

been added around the inside edge to deepen the color, which has then been blended into the paler color. Each tiny pearl has been individually painted dot by dot in white with a touch of a shimmer in it, possibly from fish scales.

The painting of the Shah's wife has even more detail. There are six chains of pearls around her neck with loops of pearls hanging below them. Her sash is underpainted with red, then extremely fine lines of gold are painted in perfect diagonal lines between the pearls.

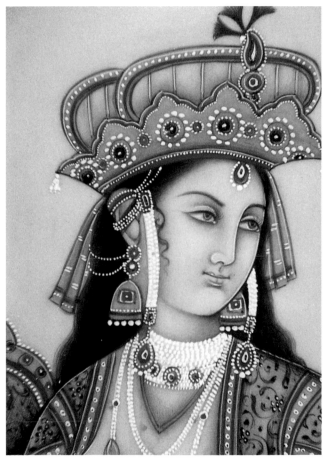

MUMTAZ MAHAL (DETAIL)

Note the incredible detail in the earrings. Her hair has been painted in fine strands, then blended and brought to a soft edge against the ivory.

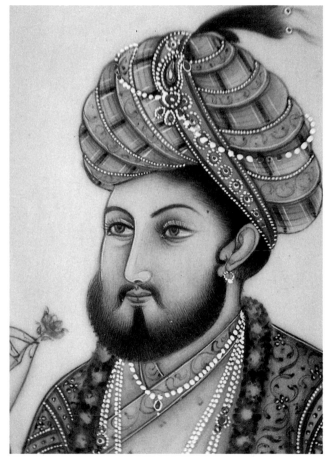

SHAH JAHAN (DETAIL)

The head and turban, showing the tiniest of flowers laid on a pale gold, together with more shimmering pearls.

When miniature portraits were exchanged, the realistic details showing that the subjects wore fine robes and jewels made an important statement. Prospective brides and grooms could impress those to whom they were betrothed with their wealth as well as their good looks.

The Flemish limners were known to have taken the art of illumination that contained portraits to England. In England portrait miniatures became highly popular.

Serving their purpose of identification, they evolved as jewelry. Miniatures were never considered for wall or table decoration until the Victorian era. They were kept in boxes in cabinets, and were brought out for viewing at family celebrations, or they were worn as jewelry in closed pendants—for light would fade the watercolors—and in pins and bracelets.

From France and Germany came the idea of enamel portraits which could be worn without being covered, and miniatures eventually became decorations for snuff boxes and other small objects.

In 1700, Rosalba Carreira of Venice introduced miniature portraits painted on ivory to England. The luminous ground, reflecting back so much of the light, made enchanting portraits, and very quickly became the ground of choice. Backgrounds became less brilliant, and colors became softer and well balanced.

SUBJECT MINIATURES

Paintings other than portraits were called subject miniatures. These were historic scenes and landscapes, and many featured flowers, some painted actual size. Copies of large landscapes were commonly made in miniature. One (in the Victoria and Albert Museum in London) is a tiny copy of Titian's *The Flight into Egypt*. This copy, measuring 6 x 9 9/16", was made by Peter Oliver for King Charles I.

Painters were often required to look at the large paintings in baronial halls and paint them in miniature technique, in a portable size, with all the important features of hair, jewelry, and dress included. Women as well as men, working by day and by candlelight, painted the miniatures. The miniator would view the work through a little magnifying glass attached to a cord worn around the neck.

Samuel Pepys, in his famous diary of this period (1660–69), was the first to describe miniatures as paintings "in the little."

Copying the detail of the larger paintings took enormous skill. This kind of work, like trompe l'oeil realism, incorporation of gold and precious stones, and setting miniature paintings in jewelry, has become part of a beautiful tradition.

THE NEW WORLD

The European style of the miniature was intensely popular in America, transported there by the settlers. The miniatures of the New World are distinguished not so much by a change of technique as by the style of the painter and the dress of the sitter. In 1782, Charles Peale opened a painting gallery specializing in miniatures, and all the Peale family became very adept miniators. So did several thousand others, and here, as in England, business was booming.

MODERN DEVELOPMENTS

The introduction of photography in the 1800s gradually killed the trade, and the discipline itself was endangered. In 1895, miniature artist Alwyn Williams founded what eventually became the Royal Society of Miniature Painters, Sculptors, and Gravers in England. (In 1905 this organization was recognized by King Edward VII.) Today this society is one of the oldest and most prestigious in the world in the discipline of the miniature. In order to preserve the "held in the hand" tradition of the miniature, the society sets a limit of a 6 x 4" frame and picture size, and of 2" for the size of a portrait head.

Williams came to the United States in the 1930s and founded the Washington Society of Miniature Painters, Sculptors, and Gravers in 1933 (in the nation's capital). He himself painted a number of the wealthy personages of the United States and the nation's Presidents. (Both societies are still in existence; their addresses can be found in the back of this book.)

Preserving the Tradition

Miniature painting has come down to us in the West just as the Asian miniatures have, from artist to artist, and because of its near-death when photography developed, continues to need preservation by the same means.

Today, the art must be preserved without new definitions and unrelated parameters being applied to it. A miniature is *not* something "miniaturized" to one-sixth its normal size, as is now claimed in certain contemporary circles. It is a definite technique which, if not correctly interpreted and followed, will be swallowed by principles that should be applied only to larger works. (One also hears of miniatures done in a "spirit of miniaturism," which is also specious.)

Unfortunately, some groups today try to make "one-sixth of actual size" a rule. This does little to help a miniature painter compose for a small size, and can be most misleading, in that a beginning miniaturist thinks that painting small is all that is required to paint a miniature. The subtle placement of secondary objects pointing toward a focal point (as in *The Broken Gate* on page 57, where branches lean toward a pathway) is an instance of the compositional art involved in miniature painting. The simple reduction of things to one-sixth their size or smaller obfuscates the art of subtly indicating the picture's focal point. Clearly, if one-sixth rules prevail over tradition, the wonderful paintings of butterflies in *actual size* and set in pendants and bracelets — very popular in early Victorian times — will no longer be seen. The forget-me-not, a tiny wildflower, cannot and should not be painted at one-sixth its size.

During an exhibition of miniatures a visitor asked me, "Is this shrink art?" I said, "What is shrink art?" The visitor replied, "They told me this was the art of miniaturism, so I thought you painted these pictures big in a special paint on plastic, then put them in the oven and miniaturized them." The application of the one-sixth rule smacks of the same reasoning.

Today's serious collectors of miniatures know and look for the traditional technique. No mechanical basis for the work should be adhered to. In the early days of photography, the photographer who also specialized in coloring photographs found a way to print a negative on ivory. In much the same way as he would retouch photographs, he would paint over the negative, and sell it as a miniature. Overpainting a print took much less time to do, and the paintings were therefore sold at low prices and in great volume. Tricks such as this were a part of the reason that the true painter of miniatures lost business. Today, many of these so-called miniatures are unwittingly sold as antique original paintings. Since many are extremely well done, collectors must exercise caution!

Of Special Interest for the Miniature Painter

There are several disciplines linked to painting miniatures that provide economic opportunities. Painters of porcelains, for example, enter into the discipline of the miniature. The subject miniature and the portrait miniature have been frequently painted on porcelain, fired, and set into a small box or pendant. Many beautiful examples have survived over the last 500 years. Many are miracles of detailed work, some with gold added. There is still a market for this art today.

One very important link to the miniature is, of course, calligraphy. Calligraphers who become skilled in illumination are relatively few. Those who develop skills in miniature painting—and vice versa—also will increase their clientele.

Heraldry Another discipline related to that of the miniature is heraldry. Heralds were appointed by the medieval courts to do all the odd jobs required by the king and his attendants. They were expected to be writers of letters and sonnets, illuminators and scribes, secretaries and painters of both the heraldic coats of arms and miniatures on important documents. They even counted the dead after a battle, and frequently decided the winner! The winner was the lord with the fewest dead men on the field. The men wore the emblems of their masters on their shields and surcoats—emblems designed by the heralds of both sides.

Many of the artists who design and paint the coats of arms for registration today are also calligraphers and miniaturists.

Copying Photographs Whereas photography may have put a serious dent in the practice of miniature painting, many people today have cherished old black-and-white photographs that serve as the basis for miniatures in color. I delight in

making a painting of the people of the past and giving them new life.

There is a ready market for this type of miniature painting. The lace and draperies of the clothes, the

According to her descendants this young woman had a fondness for green, so I painted her, referring to her old photograph, wearing green taffeta. I set a gold pin at her throat and, in that pin, set a diamond.

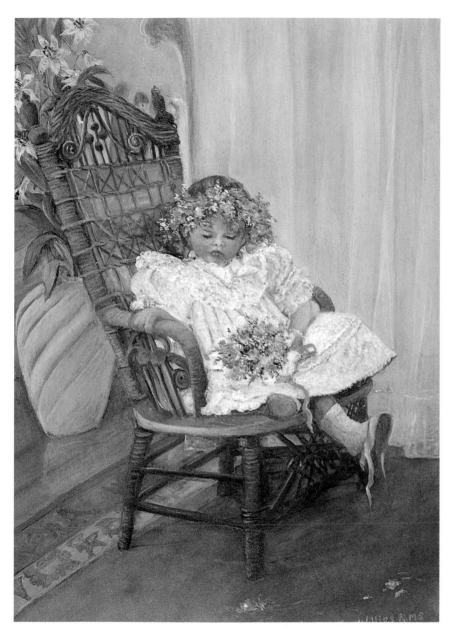

hairstyles, and the accouterments make a challenging and stimulating experience. Gold can be used to enhance these paintings also—a subject we will cover in section 12.

One painting of a young girl was taken from an old and faded sepia photograph. Fortunately, I was still able to study this person's face and capture her likeness. I painted the dress and all its flounces first, and the lace collar last. If you see lace on a dress, or on a table, always paint what is underneath the lace first of all, then add the lace.

Pictures for Dollhouses Dollhouse collectors employ the skills of artisans and artists and keep up a tradition of collectors' dollhouses—remarkable miniature assemblages which were never playthings but served as representations of life in a particular century. These have been popular since the fifteenth century on several continents.

Once you have mastered miniatures in the larger size, you will be able to paint miniatures for these

THE WEARY FLOWER GIRL
5 x 7"

For this picture done in oils and alkyds I used a chair from an old photograph and seated an imaginary child in it! The child is wearing a tiny necklace and bracelet of 23-karat shell gold.

collectors also. There are still very few painters with skill enough in using the brush, applying glazes, and rendering detail to be able to satisfy this particular market.

Knowledgeable collectors are experts in recognizing highly skilled work. Miniatures can be as large as 2½ x 2", the size of a painting that can fit over a doll-size mantelpiece. (The scale is 1" to the foot.) Of course, the content of the painting cannot be a couple of apples if, when blown up to actual room size, they would look like melons. They would have to be properly composed for a real-life room.

EMULATING THE PAST

Because miniatures up to the time of Queen Victoria were worn in a closed locket or kept in cabinets, they have retained all the freshness of their coloring to delight our eyes today. Many of the colors were fugitive, so we are most fortunate that the people of the past preserved them. With all the many developments in color available to us today, we can emulate the brilliant colors used in medieval times. We have also to emulate their skill.

The art of the miniature combines that of calligraphy and manuscript illumination—arts nowadays practiced separately most of the time. Still, these are practiced in combination by a few people. One of the finest is Henry Saxon of England. The late Jan Markut of the United States, originally from Poland, who was responsible for the painting of a phenomenal set of portrait miniatures of every President of the United States, was another such master.

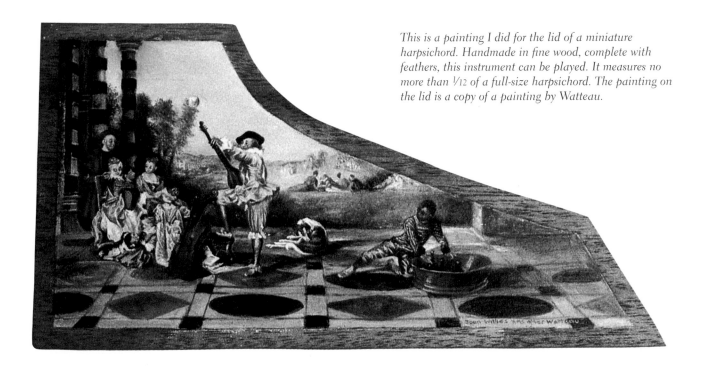

This is a painting I did for the lid of a miniature harpsichord. Handmade in fine wood, complete with feathers, this instrument can be played. It measures no more than 1/12 of a full-size harpsichord. The painting on the lid is a copy of a painting by Watteau.

Perhaps not just anyone can learn to link these three disciplines, but with enough interest and practice certainly there are talented miniature painters who will draw upon the past to produce works worthy of a great tradition.

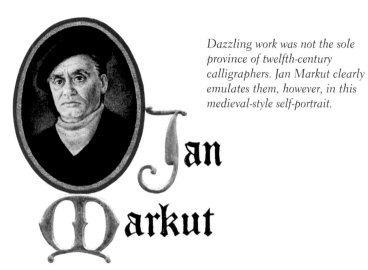

Dazzling work was not the sole province of twelfth-century calligraphers. Jan Markut clearly emulates them, however, in this medieval-style self-portrait.

K FOR KIM

I used gold leaf on vellum for the illuminated capital K, in which I painted this man's portrait—an application of materials and concepts from the past.

JAN MARKUT: CHRISTMAS

The artist has raised the highly burnished, pure gold of the illuminated capital C. Note the balance of the words and decorative flowers, rendered in watercolor.

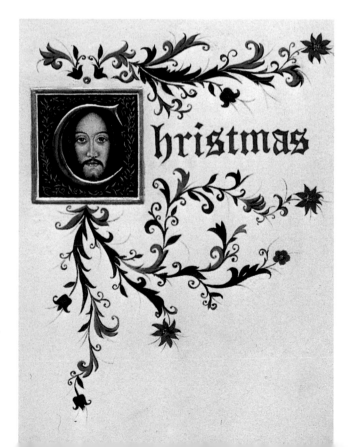

23

 MATERIALS

Of first importance to any painting are the materials you use. Your brushes, for example, are an extension of your arm, and you are only as good as your brushes. Purchase of materials for your miniature paintings should be done with care and attention. Always buy the best you can afford.

PAINTS

Whatever medium you paint with—oil, watercolor, gouache, or acrylic—it is the binder that gives the paint its name. Pigments are mostly the same from medium to medium. The binder is the gel which holds the pigments together. For example, to make oil paints the pigments are ground to a very fine powder and mixed with a binder of vegetable oil.

Oils and Alkyds

Oil paint's binder is slow-drying. In the last three hundred years resins have been added to the oils in an attempt to shorten their drying time. Resins obtained from trees and plants and added to the oil strengthen the paint film and also heightens the color of the pigments.

All alkyd colors, so far, are made only by Winsor & Newton, whose chemists made resins from plant fatty acids and organic alcohols, producing a transparent binder which could be diluted with turpentine and mineral spirits. The advantages to the miniature painter of using this alkyd medium are many. It produces a film that, when dry, is flexible and resistant to solvents. Mixed with pigments, it dries more quickly than an oil binder, yet more slowly than paints with a plastic resin (acrylics). But that is a requirement of many artists so that delicate blending can be done.

Oil vs. Alkyd Traditionally, miniatures were painted in water-soluble colors, but when oil painting was introduced, painters tried oils. Artists in those days ground their own pigments into the binder. They found that their colors mixed with oils tended to produce thick paint that was ugly on the nonabsorbent ivory surface. The introduction of machine grinding brought some improvement, but oil on the nonabsorbent surface remained a problem; there were still the slow drying time and the attraction of dust. With the eventual perfection of alkyds, artists had a perfect underpainting medium for oils on all surfaces, for alkyds and oils will mix. And used together they shorten drying time.

I used to find the oils' slow drying time to be a problem because of the accumulation of dust. However, the glowing luminosity of oil colors kept me at it. With the introduction of alkyds, I found the perfect way to paint a miniature, especially on ivory or ivorine and, indeed, on some parchments like vegetal parchment. Alkyds mixed with oils dry slower, yet still allow the delicate blending that miniatures require.

When painting with alkyds and oils, always treat alkyds as lean, and oil as fat. Use the old law of *fat over lean, never lean over fat.*

Mediums A resin medium developed to thin your alkyd colors is Winsor & Newton's Liquin. The viscosity of Liquin might be too thick for painters working on a small and nonabsorbent ground. Mr. Wendel Upchurch of Winsor & Newton developed the following recipe for me (hereafter I will refer to this mixture as *recipe*):

Fill a small screw-top jar halfway with Liquin. Fill the remaining 50 percent with Winsor & Newton

Refined Odorless Thinner. Stir well. With an eye dropper add *only* one drop of poppy oil per two teaspoonfuls (more or less) of the mixture. Immediately close the lid of your mixture tightly.

Be sure to use a small jar and fill it to the top to preserve the longevity of the recipe. Oxygen getting into the mixture will cause it to go "cheesy" within a week or two. When you use this recipe, dispense some into a small glass or metal receptacle (not plastic). It is good practice always to dispense your mediums into little containers, closing the lid of the manufacturer's jar right away. Many such mediums will degrade if left open.

In a technique called *isolating*, the masters used to spread a thin layer of amber to separate layers of paint. This serves to increase a painting's luminosity. Amber is not available

Oil and Alkyd Mediums

Grumbacher Oil Painting
 Medium 1

Winsor & Newton Liquin

Winsor & Newton Odorless
 Thinner

Poppy oil, any brand

Artists' mineral spirits

these days for this purpose, so I use this recipe. Linseed oil could be used, but it tends to darken colors, and is slow-drying.

Isolating varnishes are available to the artist, but they may be a little thick for the miniature. If you do try a varnish, it must be made especially for that purpose. Don't experiment, for the long-term damage to your work may be considerable, and *never* use photo varnishes for isolation. The isolation layer should be extremely thin and applied with a paper towel, not a brush.

Instead of mineral spirits, Weber's Turpenoid is also acceptable; it does not contain turpentine. You should never use turpentine, for this is a resin extract and too greasy for work on ivory, ivorine, or similar grounds.

A useful tip that will help you to save mineral spirits: pour your used fluid through a coffee filter, held with a rubber band over a clean jar. Whatever you do, don't throw mineral spirits down the sink or toilet. Soak up the liquid with a paper towel, and when the towel is dry, put it in the garbage *outside* your home. It will dry very quickly on the towel.

Never keep rags or towels with medium or mineral spirits on them in the house.

Painting first with alkyd diluted with Medium 1, or even Winsor & Newton's odorless and highly refined

thinner, gives a good adherence to the ground and a good ground for the adherence of additional glazes. Alkyds blend well and softly, particularly when Winsor & Newton's Liquin is used.

When you want the alkyds to take a little longer to dry, you can add one part oil to two parts alkyd. This will allow softer blending and more transparent glazing. Subsequent layers of oil plus alkyd can be laid on top of an oil and alkyd layer. If more transparency is required, finish up with oil alone. This way you are not putting "neat" alkyd over oil.

Watercolors

Pulverized gum arabic, a vehicle for binding finely ground pigments, is combined with glucose, glycerin, ox gall, and a preservative to make transparent watercolors and gouache. The grinding of watercolor pigment particles must bring them to the greatest possible fineness. This is where long experience in manufacture is important, and the artist should select the product of a company with a well-established reputation for quality manufacture of artists' colors. Winsor & Newton and Schmincke are two companies at the top of the list especially for watercolors.

In purchasing watercolors, select only *artists' colors*, not those made for student use.

Most colors are today ground by machinery. There are still a few which are ground by hand, but understandably they are very expensive. Genuine ultramarine blue made from lapis lazuli (not easy to find in a grade suitable for grinding pure color) can still be obtained. French ultramarine is commonly used as a replacement for genuine ultramarine but unfortunately does not exactly match its glory.

Similarly, genuine rose madder, which comes from the root of the madder plant, also requires hand preparation. Alazarin crimson is a close, but synthetic, approximation of rose madder.

Whenever you are traveling and see an art store closing out or a garage sale where a box of paints is offered, stop and look there for colors labelled genuine, or for tubes more than twenty years old, and treasure them for your important work—if you are lucky enough to find them!

Certain watercolor pigments are called *staining colors* because the color is not easily removed once applied. On the whole, the following will stain the painting surface, but are still able to be lifted off of ivorine: Prussian blue, cadmium red, cadmium deep, chrome yellow, chrome orange, Indian red, Indian yellow, olive green, raw sienna, Van Dyke brown, phthalocyanine green.

Most of the remainder of the popular colors all stain well, and are *not* easy to lift off from ivorine. Finally, the cobalt blues and violets stain the least.

Watercolor can be mixed with gouache, tempera, and acrylics (all of which are water-based); it is then called *aquarelle*.

Ox gall, a wetting agent, can be added to your water or used undiluted. I use it when I want to retard the drying of the paint, for instance for lift-off effects when the paint is still tacky. It is useful in wash colors and for colors dropped in to create effects. On ivorine, one should use it a bit diluted to guard against any likelihood of the paint flaking.

Gum arabic mixed with water will provide additional luminosity and helps you add second layers of paint. One has to use it very moderately, for over a period of time stickiness from the gum can rise to the surface of the painting. This has happened to many miniatures from earlier centuries when gum arabic was very popular.

There are a number of watercolor mediums and prepared sizes on the market. Use them in moderation, diluted with water, when painting a miniature. Distilled water is always preferable to tap water, which contains salts and impurities which could affect the painting, causing cloudiness.

Your water's impurities can affect the permanence of the work. (If you are painting on the beach, never use salt water to clean brushes, and do not mix paint with it!) If you cannot find distilled water, use filtered water for mixing paint.

Sugar in water used as a medium makes the paint brush well; however, insects are attracted to paintings with a sugar medium, so beware.

Gouache This water-based paint is made by the addition of precipitated chalk and titanium to a gum and approximately 50 percent pigment solution. The name "gouache" comes from the French, meaning opaque. Whereas a watercolor reflects light from the white ivorine or paper, gouache reflects from the surface of the paint itself. It can be used to highlight transparent watercolors. It can be thinned to a semi-transparency. Because of its opacity, it is used more in commercial art than in the fine arts. Yet, used in moderation, gouache can produce lovely effects. It is particularly useful in illuminating a manuscript and in heraldry, both of which are related to the art of the miniature.

Designers' gouache was produced for advertising or other commercial uses, and permanency was not of major importance. If you wish to use

designers' gouache, check its permanency rating. Winsor & Newton offers a range of finely ground designers' colors with permanency ratings given on the tube. These are intermixable with transparent watercolors, acrylics, and tempera.

Ox gall used with gouache on a plate bristol surface will help to prevent streaking and beading of the color.

Acrylics

Since the late 1960s, several manufacturers have worked to produce a totally lightfast transparent medium—acrylic paints. Even though both the plastic resin and the paint are modern, the technique of painting the miniature retains the same parameters. I have experimented with acrylics for some time, painting miniatures on ivorine. There are a number of good brands; I have come to prefer Rotring Transparent Liquid Artists' Colors, produced by Koh-I-Noor, which also owns M. Grumbacher, Inc. Winsor & Newton and Schmincke also produce very good acrylics for miniature painting.

Distinguished from the thicker acrylics sold in tubes, transparent acrylics can be diluted with water to any degree of transparency. They are strong used without dilution. Used with a retarder medium, such as Rotring Transparent Acrylic

Retarder, the paint will be paler and easy to soften and blend. It can also be used on glass, transparent films, and plastics.

Transparent acrylics have the added advantage that the liquid will run successfully through a Rapidograph pen. Developed mainly for the airbrush artist, transparent acrylic colors (mixed with retarder medium) used with a brush on ivorine, plate bristol, vellum, or vegetal parchment can give you beautiful, luminous results.

For opaque liquid acrylic colors, dilute the paint less. You can use it the same way as gouache, making light reflect back from the surface.

Transparent acrylic colors are also supplied in bottles with dropper tops. When you make a color you especially like, you can chart the number of drops of each color you mix, and come up with exactly the same color each time you want it. (Keep a separate container for each color. It will dry in the pot and fresh drops of the same color can be dropped in as required.) The color dries fairly quickly, so I use quite a bit of retarder, which delays drying as ox gall does with watercolors.

The same brushes as used with watercolor can be used for acrylics, but each time you lay down a brush, or before using a new color, you should rinse it in distilled water. Never let the

acrylic paint dry on the brush, or it will be ruined. A final cleanup should be done with soapy water.

Interference Colors In sections 11 and 12, I include *interference colors* in the palette. These paints have a special shimmering quality in their reflection of light. For centuries, abalone, fish scales, and mica have been used by painters to give a shimmer to paintings of precious gems. These were difficult to use. In this century, color manufacturers have experimented with iridescent ingredients and have been successful in producing colors which have the radiant effect we associate with mother-of-pearl.

Interference (and iridescent and pearlescent) pigments comprise a group of pigments that split light and reflect it from more than one surface. Shells and pearls contain layers of micro-thin mother-of-pearl. Each thin, filmy layer *interferes* with the long and short light waves, reflecting colors which change with every variation in the light.

In interference pigments, mica platelets of various sizes and at different angles have a satiny luster or a sparkle. Manufacturers coat these minuscule mica particles with metal oxides in differing layers. The thickness of each layer is carefully controlled. The end result is a

shimmer of light. Mixing a little with oil, water, or acrylic colors produces an effect that can be momentarily glimpsed, then disappears. One can paint an illuminated manuscript with these colors or add subtle effects to paintings of draperies, bird and butterfly wings, soap bubbles, or precious stones.

WATERCOLOR PENCILS

You can use watercolor pencils for drawing your subject, whatever paint you will be using. The Derwent brand of pencils are particularly good, but any type is acceptable so long as they are indeed watercolor. You need only a few: gray, yellow ochre, brown, red, blue, and green for your basic needs, or purchase a box of six basic colors.

GROUNDS

The base material for a painting can be referred to as "the ground" or as "the support." The surface of the ground for a miniature painting should be white. This is because light reflects from a white surface, and because the paints used for a miniature are mostly transparent. The light reflected from the white ground through the layers of paint gives the miniature its special luminosity.

Grounds can be ivory, ivorine, vellum, vegetal parchment, card, paper, or metal. Beaten copper, for instance, has been used for a miniature; however, the area painted in light colors must receive a base coat of white gesso.

Ivory Long considered the most beautiful ground for a miniature, ivory is now seldom used because of the threat to elephant populations. Today, one cannot take ivory across most international borders.

Ivorine The nearest material to ivory is the artificial *ivorine*. The ivorine surface contains a mass of crystals that reflect light in the same way as those of ivory but contains no real ivory. How the substitute crystals are made, and how they are made to adhere to the polyester surface, is known only to its few manufacturers in England.

Ivory and ivorine need the same care. Both will curve if exposed to heat above about 70 degrees Fahrenheit. Ivory will crack. Ivorine

PEACHES

This painting, shown actual size, was done on ivorine with transparent liquid acrylics, which give a beautifully luminous quality to the subject.

will bend but cannot be restored to its original flatness if it warps.

The ivorine you work on *must be cleaned* by washing it in warm detergent water. A slight sanding with a clean scrubber which has not been used for sanding oils is also advisable.

Ivorine must be kept absolutely free of oils from the skin and be mounted on foam-core board or protected by a mat and glass. Do not mount ivorine on mat board; it is not strong enough to prevent the ivorine from curving.

Egg tempera tends to flake off when painted on ivorine, and I do not recommend its use on ivorine. Watercolor can be used, but the color must be kept diluted and not be built up heavily.

Vellum Painting in watercolor on vellum goes back to the 8th century. Vellum is leather, made from the skin of lambs or calves which do not come to term. Thus it is expensive and somewhat scarce. The finest vellum comes from the hairless inside of the calf's belly. The skin is dressed with pumice powder for additional smoothness. The color is off-white or creamy white. It is a delightful ground on which to paint a miniature. It will take oil, alkyd, egg tempera, gouache, watercolor, and acrylics.

One thing you can do on vellum which you cannot do on paper is put on many layers of color. Paint sinks in a little, but the surface has unique luminous qualities. Color will not lift off completely, but neither will the surface break up as with paper, especially if you use a clean piece of silk to burnish it once it is perfectly dry. After burnishing, color will be more resistant to coming off when a next glaze is applied.

Vellum must be handled with care by the edges only. If fingers touch it, they will deposit some oil even if the hands are clean. A piece of fresh white bread rubbed gently over the area will remove the oil.

Vellum must be kept dry and flat. Care must be taken insofar as it will puff into a bubble or buckle if wetted too much—that is, with more water than could be applied with a small brush. It must be mounted and set behind a mat and glass even if painted in oils or acrylics. It may be mounted on acid-free card or a foam-core board.

Vellum also attracts mold, so you are advised to protect your vellum pictures from time to time in a drawer along with some camphor or a good scattering of moth balls. Leave them there for a week or two. Mold spores look like soft brown dots, gathering first around the edge of the miniature under the glass. If you see this, remove the frame and dust the brown off with a camel-hair brush, then give them the camphor treatment.

Parchment There are various parchments which range from a pale cream to yellow ochre and brown; they are made from sheep, goat, or pig skin. All have a visible grain and are thicker and coarser than vellum. The grain makes an attractive background. I paint it with gesso first and sand it before painting, often leaving the background area untouched.

Vegetal parchment is available from Miniature Painting, Etc. (see the suppliers list in the appendix). This parchment, made in Italy, reacts to wetness like vellum does. It can be painted on successfully with watercolors, but not with a very wet technique. It should receive a base spray of either Rabbit Skin glue or a clear acrylic resin spray because the parchment should never be allowed to become saturated. Therefore glazes must be thin and blotted after application. Each layer should be thoroughly dry before applying a second layer.

Parchment is much less expensive than vellum, and odd pieces can sometimes be purchased by the pound from suppliers who specialize in calligraphy materials.

Plate Bristol Plate bristol is a hot-pressed glossy or matte card good for alkyd and water-based colors. "Hot-pressed" means that the card is

pressed with heat, giving it a smooth surface. Plate bristol is made with more weight and pressure than hot-pressed paper. (Hot-pressed paper is also used for miniatures, of course, because of its hard surface.) I recommend using three- or four-ply plate bristol; these offer more rigidity. (The card does come in one- and two-ply also.) If three- or four-ply is held down by a mat and glass it does not need to be mounted, but I suggest that you mount the one- and two-ply.

The surface is hard and somewhat like porcelain. It will allow more lift-off of color than any other card surface (though it is not as good-natured as ivorine). There is, however, some staining that cannot be lifted off.

Plate bristol takes many more glazes than paper. Paint sinks in a little, whereas paint on ivorine sits on the surface.

Other Surfaces Matte bristol board is a good surface for watercolor paintings. As I discuss later in a watercolor section, the board is not wetted when painting in miniature technique. Paint is mixed to a creamy consistency on the palette and applied in thin layers of medium wetness.

Wood can be used, but it has to be well sealed and finely sanded, then coated with at least ten to twenty thin coats of gesso (sanding well between coats). Fine-grained wood, cut thinly for marquetry, must be mounted on foam-core board to prevent it from rising and curving.

Acrylic, alkyd, or oil paint can be used on wood. The finished work needs to be well varnished with several coats.

Hardboard requires the same treatment on its smooth side. (The coarse side of hardboard is not at all suitable.) Gesso should be well polished between layers and on the final layer. Paint will sink into it, however, and the colors will become dull. Hardboard has a tendency to crack in some temperatures and can swell and distort. If you are able to do quality work, painting on hardboard is rather like setting a diamond in a plastic ring. Practice on it, but do not offer it for sale!

A piece of ivory-colored Plexiglas with the polish sanded off makes an excellent palette to practice brush-strokes and test out mixtures before you apply them to your painting, but it is not for finished paintings. There is no information about durability and effect on colors over time, and I advise you to use a support that has a history of use for at least fifty years. Pieces of Plexiglas are, moreover, usually too thick to use for a miniature.

Plexiglas can be cleaned of oil or alkyd color with mineral spirits, and of watercolor with water. Acrylics, however, will stain it.

Canvas board, unless specially made with very fine texture, is not suitable for miniatures. You will need to gesso again and again until you have a smooth surface. Belgian linen portrait canvas, if triple-primed, can be used. The problem is in mounting it. Stretchers have to be ½" in thickness. Sometimes 5 x 7" stretcher frames can be found on which a framer could stretch linen for you. I have seen 3 x 4" stretchers. The thickness of the stretcher must not be thicker than the depth of the frame. An 8 x 6" miniature would look good in a ¾" molding, and it is easier to obtain stretchers that will fit inside the ¾" molding.

It is most important to ensure that any surface upon which your ground is mounted is acid-free. Many good miniatures from the past have been eaten away by acids contained in the backing materials.

BRUSHES

I have always saved money by buying the more expensive, high-quality brushes, for one good brush lasts as long as three cheaper ones.

For the demonstrations in this book I list the brush sizes I used for the pictures. I recommend that you have in your stock the following brushes in several sizes. Please note

that sable brushes used for miniatures must have a good reservoir, tapering to a point. Those mentioned here have this quality.

Sable Brushes

Winsor & Newton, series 7 and 12

Da Vinci Cosmos, series 15-06 (Joan Willies)

Da Vinci Cosmos, series 10 (Joan Willies)

Da Vinci Maestro, series 10

Da Vinci Restauro, series 5506

Silver Brush kolinsky, series 7000S

Synthetic Brushes

Da Vinci Cosmotop, series 5580 (Joan Willies) "Spin"

Da Vinci Nova, series 1373 (Joan Willies) angle

Winsor & Newton Regency 560 angle

Winsor & Newton, series 550 filbert

Silver Golden natural-synthetic 2006S angle

Silver Golden natural-synthetic 2000S round

Soft Blenders (Mops)

Loew Cornell mini-mop

Loew Cornell Ann's detail mop

The "Spin" brush listed here is quite handy. Its slightly rounded tip comes to a good point, but also flattens nicely to do very small stipples.

As a rule, your blenders, or mops, should not be cleaned in mineral spirits until you have finished your day's work. When you are working, each time you touch the work to blend color, wipe the mop on a paper towel. If the towel no longer cleans it, too much paint has built up on the bristles and they will get scratchy. In that case, you will need to wash the brush in mineral spirits (thinner) and then dishwasher detergent and allow it to dry. Therefore it is a good idea to purchase at least two mops so that you can work with a dry one while the wet one is drying.

You will notice throughout the text that I change brushes often when painting. Of course, the shape or thickness of the brush is important to whatever strokes you need to do. Too big a brush in a small area may pick up some of an adjacent color and streak the color you are using. For the tiniest of details, you may wish to purchase a Da Vinci 10-zero (#0000000000) brush—a rare species, but excellent.

Using several good brushes of similar size also spreads out their wear. As brushes wear they take on a new personality. One gets fond of them, and they are used preferentially all the time. Suddenly, when you need them, they are too worn. Therefore I use several at the same rate, so that I have a few favorites to fall back on at all times.

In addition to brushes, keep handy a supply of paper towels or lint-free rags, such as old tee-shirts, for wiping and blotting.

Care of Brushes At the end of each painting session, be sure to rinse your brushes in mineral spirits. Then wash them in warm water and dishwasher detergent. The life of your expensive brushes will be extended.

Never allow alkyd or oil to dry on brushes. Once set, the paint will never come out. Once a month wash your brushes with a good hair shampoo for dry hair. Use hair conditioner as well. This will keep your sables (and blenders in particular) very soft. Shape sables to a point in the hand and stand them heads up to dry. *Never* leave a brush standing on its head in mineral spirits or in a jar.

Palette
A plastic palette, a white china plate, or a plastic-coated picnic plate can be used for watercolor. But for any and all of the mediums I recommend you use a white disposable palette pad. Tear off a sheet and fold it to fit your easel (see illustration). This pad is especially

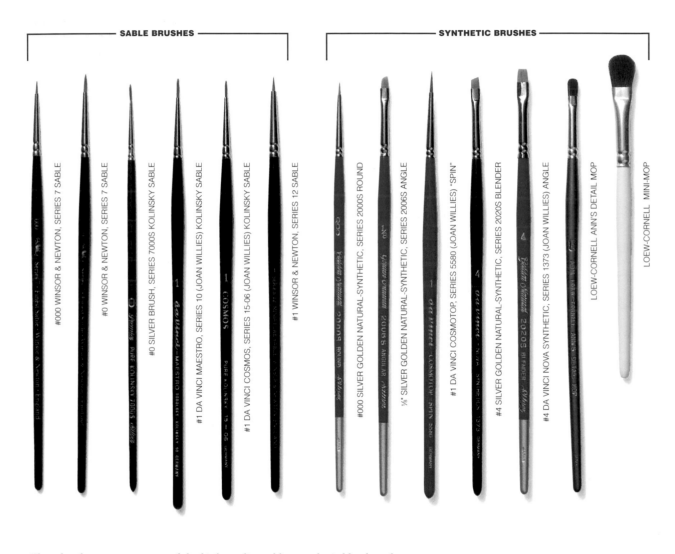

SABLE BRUSHES

SYNTHETIC BRUSHES

#000 WINSOR & NEWTON, SERIES 7 SABLE

#0 WINSOR & NEWTON, SERIES 7 SABLE

#0 SILVER BRUSH, SERIES 7000S KOLINSKY SABLE

#1 DA VINCI MAESTRO, SERIES 10 (JOAN WILLIES) KOLINSKY SABLE

#1 DA VINCI COSMOS, SERIES 15-06 (JOAN WILLIES) KOLINSKY SABLE

#1 WINSOR & NEWTON, SERIES 12 SABLE

#000 SILVER GOLDEN NATURAL-SYNTHETIC, SERIES 2000S ROUND

⅛" SILVER GOLDEN NATURAL-SYNTHETIC, SERIES 2006S ANGLE

#1 DA VINCI COSMOTOP, SERIES 5580 (JOAN WILLIES) "SPIN"

#4 SILVER GOLDEN NATURAL-SYNTHETIC, SERIES 2020S BLENDER

#4 DA VINCI NOVA SYNTHETIC, SERIES 1373 (JOAN WILLIES) ANGLE

LOEW-CORNELL ANN'S DETAIL MOP

LOEW-CORNELL MINI-MOP

These brushes represent some of the high-quality sables, synthetic-blend, and synthetic brushes that miniature painters should have to achieve good results in their work. Always buy the best you can afford.

good for oils, yet the waxy surface can be used also for watercolors and to test glazes. Because miniatures are painted on a white ground in thin layers, a white palette is needed to see the colors as they will appear on ivorine. You cannot do this with a colored palette.

There are palettes designed with lids that allow your colors to remain fresh. When I finish a painting session and wish to preserve my palette for the next session, I put it into a box, cover it, and store it in my freezer; this keeps the paint soft. I recommend that you do this no more than a couple of times with the same palette, however, for the paint film will weaken.

EASEL

I use a clear Plexiglas easel with a lip for holding brushes. This can be made into a light box by placing an under-the-counter fluorescent light on its flat back under the easel. Of course, a light box, if you have one, is useful for tracing a sketch. Another substitute for a light box is to tape a sketch to a bright window.

If you do not have an easel, put a sturdy board on a slope made from some heavy books. You must hold your brush with great control and even hold your breath when putting in a tiny detail. This puts strain upon your neck and shoulder muscles (without your always being aware of it). Therefore you should work on a sloping surface.

Magnifying Glass

There are several kinds of magnifying glass, the cheapest being obtainable from sewing shops. These are often magnifiers with lights, which can clip onto a table. They can also be found in art stores and artists' catalogs. Magnifying glasses on a gooseneck stand can sometimes be found in watchmakers' catalogs or catalogs which supply people who similarly work with small parts.

Hand-held magnifiers are easily obtainable. I'm not happy using magnifying eyeglasses (spectacles) such as jewelers use, but you may find them acceptable. You need a minimum of 2½ magnifying power—3 is even better.

Containers and Other Tools

I like to use baby food jars with screw-top lids, and also the tiny jelly jars one gets with restaurant breakfasts, as paint and water containers. Plastic jars and dishes are good for water-based paints. Plastic plates which come with microwave foods are excellent for laying out watercolors. All should be white.

A scrubber, a 3" square sponge with a layer of very fine sand affixed to it, is a most useful tool for painting in oils and alkyds. It will remove dust, hairs, and raised blobs of paint from a dry painting and give a slight tooth to the surface that will give good adherence for the second layer of paint or glaze. It is inexpensive and better than sandpaper, which can scratch the surface of the painting.

Plastic templates, especially for ovals, can be purchased in sets. The ovals in these can be somewhat too elongated. One resource is saved-up greeting cards, which frequently have cut-away ovals—I have quite a collection with various sizes. Also keep any mat which becomes marked or unusable as a template.

Finally, always have on hand both a ruler, a T-square, and erasers. Buy the kneadable erasers, which are especially good for use on ivorine.

SETTING UP

Everyone's preferences for working vary, but I recommend setting up your easel with your palette, or a 6 x 4" sheet from a palette pad, at the top of your easel (see illustration, page 34). This keeps it away from your arm. It is important to be able to rest your wrist on the slope of the easel for maximum control of the brush—certainly it helps to prevent shakiness of the hand when putting in tiny detail. Also tape your photographic reference, if any, on the top of the easel.

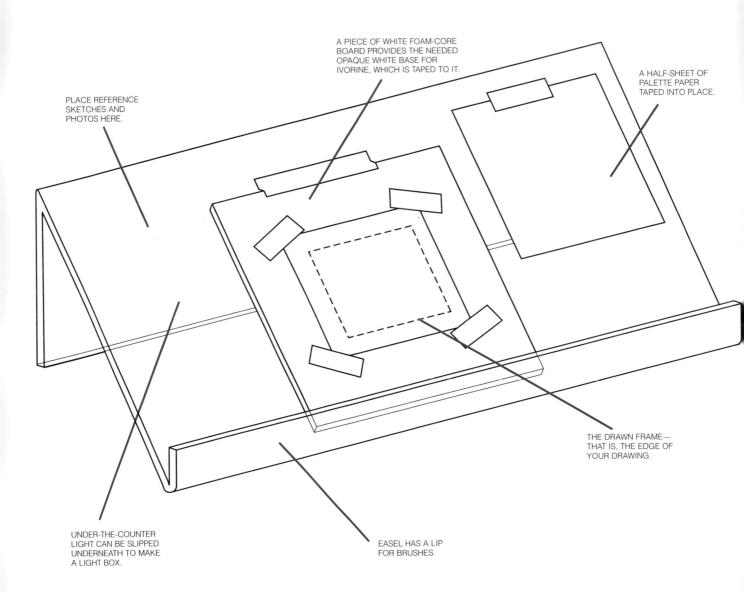

A PIECE OF WHITE FOAM-CORE BOARD PROVIDES THE NEEDED OPAQUE WHITE BASE FOR IVORINE, WHICH IS TAPED TO IT.

A HALF-SHEET OF PALETTE PAPER TAPED INTO PLACE.

PLACE REFERENCE SKETCHES AND PHOTOS HERE.

THE DRAWN FRAME— THAT IS, THE EDGE OF YOUR DRAWING.

UNDER-THE-COUNTER LIGHT CAN BE SLIPPED UNDERNEATH TO MAKE A LIGHT BOX.

EASEL HAS A LIP FOR BRUSHES.

A clear Plexiglas easel: This is the basic setup I use for doing a miniature painting, whatever the medium used.

At the center, tape mat board or foam-core board. Tape the ground on this board. Make sure that the tape holding the ground to the mat only just holds it at the corners and does not impinge upon the picture area.

A Few Precautions

Miniature painting is convenient because it can be done in a small space, but it must be well-ventilated when using oil or alkyd colors, mediums and solvents. Keep an airflow through the room, especially if it is small. Also, do not smoke or eat while using paints or mediums; some are quite toxic.

Protect your eyes. Use the magnifier for detail, even if you have good eyesight; this will relax the eye. Always work in plenty of good light. The best lighting is artificial light from magnifying lamps, supplemented by incandescent lights and daylight from windows or open doors.

You should frequently look away from your work to the farthest spot you can see. This relaxes the muscle tension in the eyes. You will not harm your eyes if you use the magnifier and rest every half-hour or so. Make looking into the distance a regular habit.

Professional Finishing

You can save money by having frames, mats, and glass cut by a framer, and finishing them off yourself. For about $25 you can obtain a spring-loaded gun which will shoot pins into the back of the frame to hold the glass, the picture, and its backing in place. Framers use a tape with glue on one side laid on the back of the frame molding. Once it is rubbed down with a finger, the tape is removed and the glue remains.

Don't attempt to cut brown backing paper to shape. Just lay a piece cut larger than the back of the frame on the glue left by the tape. Press down well and make a visible crease all around the edges. Take an X-acto knife and a ruler, lay the ruler along each edge, and *slowly* score with the knife (you do not want the knife to slip and scratch the side of the molding). Add a hanger or miniature eye hooks and framing wire. Always label the back of the picture with the title, your name and address, and, in your smallest neatest writing, caution the purchaser not to hang it near a bright window or in a hot or humid place.

When displaying the work, be aware of the difference between natural light and artificial (especially incandescent) light and check your work under both kinds. Under artificial light, such as is found in galleries, imperfections show up more readily.

3 MINIATURE PAINTING TECHNIQUES

PALETTE

Alkyds
Titanium white
Naples yellow
Cadmium yellow
Yellow ochre
Burnt sienna
Burnt umber
Rose madder
Olive green
Sap green
Payne's gray

Oil
Phthalo yellow-green

As a beginner, you must first learn the brushwork techniques of miniature painting. The key to producing a successful miniature is good brush technique. Originally painted in watercolor, miniatures consisted of tiny dots, hatched and cross-hatched strokes, and broad washes (a wash is a color diluted into a very fluid paint that is pulled across the painting surface). The following set of demonstrations will introduce you to the essential techniques for applying paint "in the little." Then we'll move on to landscape motifs, with which you will practice the brushwork using oils and alkyds. This will lead you into a lesson on your first complete painting, *The Broken Gate*.

The following demonstrations comprise the basic vocabulary of miniature painting brush technique. Study them carefully, then try to duplicate the demonstrations with the materials you own. (I recommend you try to do these on ivorine, if you can.) Follow the steps and you will become acquainted with the feel of the paint and handling of the brush.

Follow the steps *very closely*, for you should begin from the first to develop the best habits. You should, for example, habitually touch a paper towel with the brush after dipping it into any solution, whether medium or paint. *This should become a movement that you perform as naturally as breathing, as a part of your technique*—wetting the brush in medium or paint and then, with a touch to a paper towel, drawing the surplus from the bristles and ferrule to keep the liquid from running down the brush. You should also practice, until it becomes *automatic*, the shaping of your brush by flattening or twirling it in the paint and then refining its shape on the palette or with a slight touch to your paper towel. This is the only way you will gain the utmost control of the paint and medium held on your brush—a control you must attain for successful miniature painting.

MATERIALS
For these exercises, prepare your easel and palette with the alkyd and oil colors that appear in the palette box at left.

Tape a piece of ivorine on your easel. For wetting the brush and diluting the paint, dispense some Grumbacher Medium 1 into a small container. Also put out mineral spirits and "recipe" (page 25) in containers. Be sure that you ventilate the room well. Also have paper towels handy.

Set out the following brushes:

Sables: #000, #0, #1, and #2

¼" synthetic angle brush

¼" blender mop

Da Vinci #0 "Spin" brush

An old, spiky synthetic brush will also come in handy.

Applying a Glaze

1. Dip the ¼" angle brush in medium.

2. Touch the brush to the paper towel.

3. Flatten the brush in slightly watery paint.

4. Touch the brush to the towel.

5. Flatten, press, and pull the brush firmly along the surface.

Stippling

1. Dip your angle brush in medium.

2. Touch the brush to the towel.

3. Dip the brush in a thin amount of paint that is not too wet.

4. Touch the brush to the towel.

5. Hold the brush straight down or at a slight angle to dab on the paint.

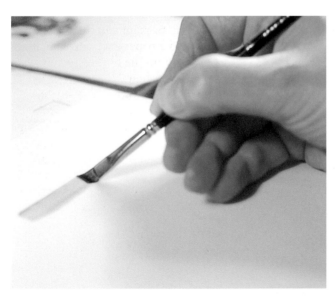

For a wash or glaze, flatten a brush such as a ¼" or ½" angle brush in very fluid paint and pull the color along.

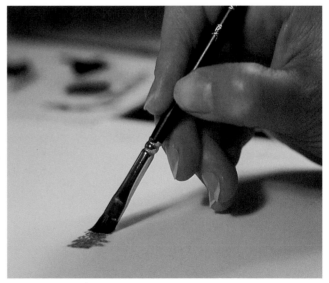

To get the right effect in stippling, the paint should be only very slightly diluted.

STIPPLING TWO COLORS

1. Dip the angle brush in medium.

2. Touch the brush to the towel.

3. Tip the brush in one, then another, color—neither should be thick.

4. Touch the brush to the towel.

5. Stipple as before and the colors will produce a variegated effect.

SOFTENING A STIPPLED EFFECT

1. Slightly flatten your blender mop.

2. Touch the wet stippled paint with the mop, using a firm, downward tap.

SOFTENING SHAPES

1. Put the blender mop on its side.

2. Touch the paint surface lightly.

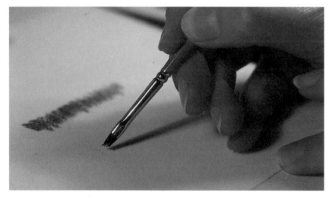

Here, the brush has been tipped in olive green, then yellow-orange. Do not pick up thick color from the blob of paint.

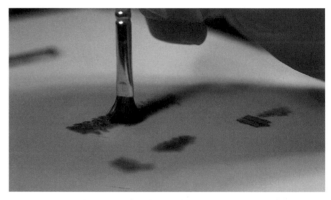

Here, a mini-mop is used to soften the stippled paint just applied.

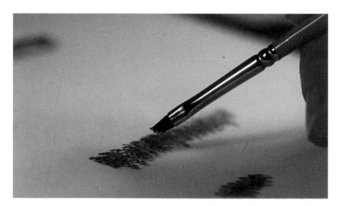

Stippling with the edge of the brush in two colors.

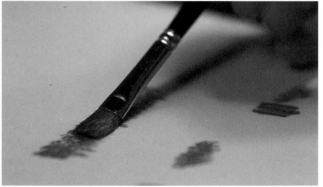

With the mop on its side, a gentle touch while the paint is still wet will soften textures and shapes without ruining them.

Painting a Fine Line

1. Dip a fine brush, such as a #0, in medium.

2. Touch the brush to the towel.

3. Lay the brush flat in fluid paint and twirl it to attain a fine point.

4. Stroke away from the paint with a slight pull as you twist your brush.

5. Touch the brush lightly to the towel and refine its point.

6. Draw using only the point.

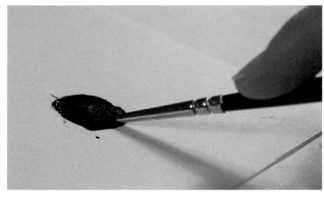

Twirl the brush (this is a #0) by giving the brush handle a twist with your fingers.

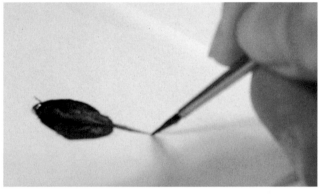

Stroke away from the color on the palette as you twist the brush.

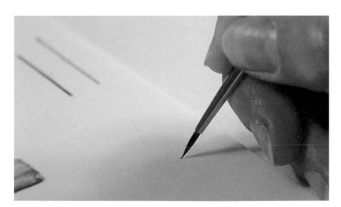

Put the brush point-down, just touching the surface.

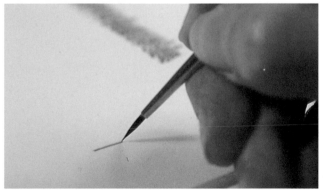

Stroke without pressing down on the brush.

LIFTING OFF PAINT

1. Dip the brush in medium.

2. Touch the brush to the towel and refine its shape.

3. To trim a shape or line, use the point to pick up the unwanted paint before it has a chance to dry.

The brush should always be held to a point when lifting off.

PAINTING A WIDE STROKE

1. Dip your brush in medium.

2. Touch the brush to the towel.

3. Flatten the brush in the paint, stroking it a bit on the palette.

4. Apply the paint with the brush flattened to give you a broad swath.

5. Apply pressure if you want a beaded line of paint to form at each side of the stroke.

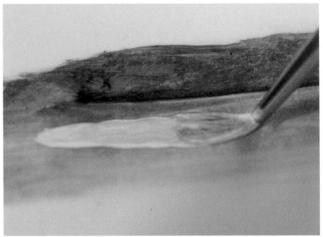

Here, white is painted over a blue-painted area. Strokes like this are useful for suggesting sea foam or a waterfall.

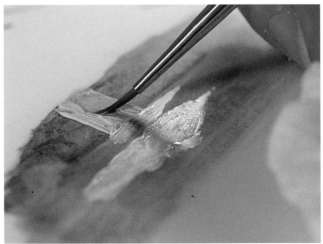

With a #1 brush dipped in medium, you can push the paint around to let the background color show through, or to draw paint away from the beaded lines.

PAINTING A MEDIUM STROKE

1. Dip the #1 brush in medium.

2. Touch the brush to the towel.

3. Twirl the brush in the paint.

4. Touch the brush to the towel.

5. With some pressure applied, pull the paint along.

This stroke could be the beginning of the foamy edge of a wave.

Lifting off paint to refine and reshape the stroke.

PAINTING A SMALL STROKE

1. Dip the brush in medium.

2. Touch the brush to the towel.

3. Twirl the brush in the paint.

4. Touch the brush to the towel

again and refine its shape.

5. Press down lightly with the point of the brush.

6. Lift the brush with a slight pulling away.

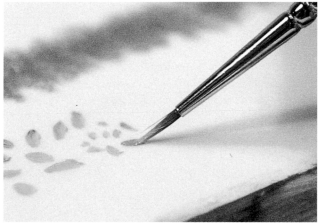

Here the brush was pointed in yellow-green and then in Payne's gray.

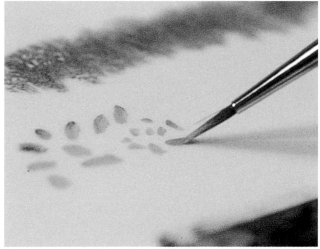

After the point is depressed, the brush is lifted with a slight pull.

Painting Tiny Specks for Texture and Highlights

1. Dip an old, spiky brush in medium.

2. Wipe the brush on the towel.

3. Holding the brush upright, place the bristles lightly in the paint.

4. Touch the brush to the towel to remove over-large drops of paint.

5. Press down lightly to make delicate specks.

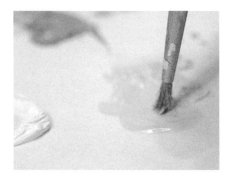

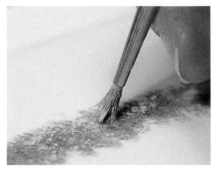

To paint tiny highlights and add texture, put the spiky brush tip lightly in the paint.

Here, distant foliage is suggested, with yellow highlights on leaves.

Cross-Hatching

1. Dip the brush in medium.

2. Touch the brush to the towel.

3. Twirl the brush in the color until the paint becomes creamy.

4. Touch the brush to the towel.

5. Draw fine lines crisscrossing each other.

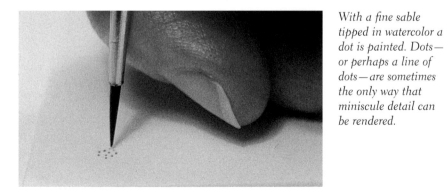

Use crisscross patterns to render latticework, netting, window panes, and the like. This is a creamy watercolor paint on a pointed #4 brush. Cross-hatching is also good for filling in backgrounds in watercolor.

Painting Dots

1. Dip the brush in medium.

2. Touch the brush to the towel.

3. Tip the brush in paint.

4. Touch the brush to the towel and refine its shape.

5. With only the very tip, place a tiny dot of color.

With a fine sable tipped in watercolor a dot is painted. Dots — or perhaps a line of dots — are sometimes the only way that miniscule detail can be rendered.

SANDING

Whenever you resume work on a painting, check to see if it is completely dry, then rub your finger lightly over the surface. If you feel roughness, this means that you have some raised paint on the surface. On a small painting, particularly after it is varnished, the roughness will show, especially if you have painted several layers. To prevent ugly lumps building up, rub the surface gently with the scrubber. It will only take off lumps and will not affect the painting itself, unless you rub too vigorously. Just rub *very lightly* and check with your finger to see if the roughness is gone. If it is, don't rub the painting again.

There is a second benefit from this gentle sanding:it raises a fine tooth on the work, and this allows the second layer of paint to grip efficiently.

As you paint more and more with these techniques, you will find that you need to take off roughness less and less.

ISOLATING

Before you start to work on a painting again, a step known as an *isolation* should be taken. To enhance its transparency, do this every time you return to work on a completely dry painting:

1. On oil and alkyd paintings, rub a small amount of "recipe" into the dry painting with a paper towel and allow it to dry. Mainly because of the poppy oil in the mixture, it will provide a thin separation between the layers of color. I avoid isolating varnishes, and absolutely *no* final or photographic varnishes should ever be used for this step!

2. On paintings using water-soluble paints, rub in acrylic retarder, *not* "recipe." (Does not apply to watercolors.)

APPLYING TECHNIQUES: LANDSCAPE MOTIFS

Do the following exercises as way of practicing the brush techniques you have just learned, and to prepare for the landscape painting lesson on pages 48 to 57. You should devote considerable time to these practice sessions so that you can develop good habits in using the brush.

PAINTING GRASSES

Stippling Lay both sides of the angle brush flat in a little of the olive green, press flat, and stroke it a bit on the palette. This way the brush is not overloaded. *The drier the brush, the better the stipple effect.* You will develop this area as follows:

1. Tip just the edge of the brush into a little burnt sienna, touch the paper towel lightly, and stipple, working the paint in a strip about an inch deep. Touch the brush to your towel and work the paint, still using a stipple action, so that the top part is lighter than the bottom.

2. Now divide the strip into four portions. In the second to fourth portions stipple over again with olive green and a little Payne's gray, keeping it a little lighter at the top. Tap the painted surface gently with a clean blender mop.

Now you will switch to a fresh sap green, so you must clean the angle brush in mineral spirits. Dip it in Medium 1.

Learn to touch your brush to a paper towel in your hand or laid near the easel in front of you.

Load the brush as before with sap green, then tip the corner with titanium white. I advise that you occasionally tap the palette paper gently to check results. Then, using the corner of the brush, lightly stipple over the dark green in the second portion of the strip to create light, mossy grass. Touch with a clean, dry mop.

Use the #000 brush to draw stalks coming out of the bushier grass with fine lines of olive green. Twirling it in the towel, roll the hairs into a fine point. Touch Payne's gray and twirl again. In painting fine lines, draw

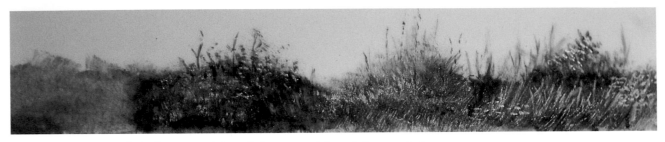

Painting grasses, you will develop many of the techniques essential to miniature painting.

the brush gently away from the paint on your palette and make some test strokes to see if the paint runs smoothly from the tip of the brush. A touch of medium may improve flow.

Use your magnifier. With the very tip of the brush, lightly draw stalks. Clean the brush in mineral spirits and repeat the process with a little rose madder and a touch of titanium white. Put in dots for pink flowers on the stalks and in the grass. If the paint is not raised, you do not need to follow through with the mop.

3. In the third portion, wet an old, spiky synthetic brush with Medium 1. Touch the towel, then touch the bristles' tips lightly onto Naples yellow. Stroke lightly upward on the dark color. With practice, you will get very thin blades of grass. Make sure you do not have blobs of paint on the bristle ends.

Repeat the stalks as before, using burnt sienna or burnt umber, then dot with cadmium yellow for yellowed grasses.

4. In the fourth portion, dip the old spiky brush (you can try different old ones for different effects) into phthalo yellow-green, then titanium white for pale green spikes. Notice that the oil–alkyd combination will draw out the grasses more smoothly. Paint in very tiny stalks and leaves in olive green with the #000 brush dipped into "recipe" (because you are now thinning alkyd paint). Touch lightly with a mop.

PAINTING PEBBLES, ROCKS, AND BRICKS

Dip the ¼" angle brush into Medium 1, then, with the brush on its side, stipple yellow ochre in a strip and spread it out without adding more paint.

Lifting Off Clean the brush in mineral spirits and, without picking up any paint, stipple to the left to lift off many tiny white dots. Wipe and re-dip the brush in your medium before each lift-off stroke. You may find this the easiest way to draw fine lines with the brush. Lift-off is one of the neatest tricks a miniaturist can acquire.

Tap gently with the mop. Make a practice of wiping surplus paint off the mop with a dry paper towel each time you use it.

Using the flat of the angle brush, pick up some burnt umber. With the corner and edge of the brush, lay in some dark gravel, leaving some of the yellow ochre and white lift-off showing between stipples. Gently tap with the mop. You can soften the dark stipples with the angle brush applied straight downwards.

Glazing When this base is dry, transparent oil–alkyd glazes can be

laid over it to create, say, the dark gravel of a road. The use of alkyd Payne's gray plus oil burnt umber, for instance, will darken the surface, but the stippled area will still show, depending upon how many glazes you layer on.

Create another strip of stippled color, then divide this into three sections:

1. In the first section, lift off curves from the stippled ground with the #0 or #1 brush. Lift smaller ones toward the back and larger ones in the front. *Clean the brush and dip and dry each time.* With the same brush dipped in Medium 1, then in alkyd olive green, feather in some tiny grass stalks between the pebbles.

2. In the second section, with a #0, #1, or #2 sable brush, lift out longer rocks, pushing the paint into a fine line while lifting. Touch in shadows on the rocks with a diluted Payne's gray. Now tint the shadowed ends of the rocks with Payne's gray. When dry, the rocks could be glazed over with transparent alkyds or alkyds plus oils.

 Highlights can be added with titanium white. A touch of lemon yellow or rose madder in the white will add sparkle to it. Light is now reflecting from the ivorine through the transparent colors, and also bouncing off the opaque white.

Painting gravel is an exercise in the technique of stippling.

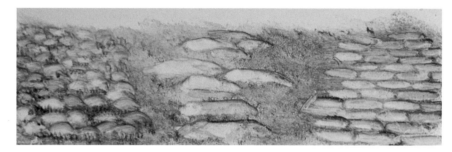

Pebbles, rocks, and bricks are related, in terms of technique.

3. In the third section, lift off bricks—small bricks toward the back, larger bricks in the front. Use the point of the brush to push back the dividing lines. Lifting off gives a much more natural appearance of linear divisions than does painting in lines later.

When this is dry, add a transparent brown glaze, using an oil, or an oil–alkyd burnt sienna (that is, burnt sienna from each medium). Allow this to dry, then reglaze. To obtain a richer color, glaze again. The bricks underneath should still show through.

PAINTING TREE BARK

Using Wide Strokes With an angle brush, firmly paint a broad, straight line of burnt umber. To widen the trunk, do another stroke. You can vary the colors by flattening the brush on both sides in burnt sienna, then touching the angled edge into burnt umber. The two colors will come out in different lines when you stroke the brush to paint the trunk.

With a #000 or #0 sable brush dipped in medium, lift off thin lines, short and long, for the divisions of the bark. Push with the point of the brush to either side of the lift-offs. Make them slightly wider on the left-hand side, and close them on the right, giving that side a darker appearance. Allow this to dry.

If you want richer color, glaze in perhaps a mixture of burnt umber and Payne's gray with a #2 brush. Dilute to a tint to start with. You can increase the depth of color with further glazes, using perhaps alkyd burnt sienna and oil Payne's gray and "recipe." You will get interesting glazes. Remember: Don't finish with alkyd, but with oil plus alkyd, or oil alone.

Lifting Off for Detail Now repeat this exercise, putting in the tree trunk first, then lifting color. This time, lift off a knot in the tree trunk: Dip the brush in Medium 1 and with a twisting movement of the brush, lift out the knot with the point. With a #000 brush twirled to a point in Payne's gray and burnt umber, dot around the knot to darken its border. Allow this to dry.

Tree bark incorporates the technique of lifting off paint.

Next, paint in the knot with Naples yellow, touching it gently with the mop. Let it dry, then glaze with a transparent alkyd, or oil plus alkyd, in the color of your choice. When it is dry, strengthen the yellow in the knot a little and add a tiny center of burnt umber or burnt sienna. Reglaze to deepen the shadow on the left, if necessary.

Do the exercise a fourth time in which you lift off longer and wider areas. Add more bark irregularities, glazing and reglazing as before.

Try creating other tree barks using lift-off technique. Bark with small triangular irregularities can be painted with overlapping lift-offs. Lift off tiny diamond shapes, then with the point of your brush lift off below the first shape, pushing a tiny line of paint upwards in a V shape. Continue like this across and down the bark of the tree.

If you apply your blender mop straight downwards, it will blend out some of the tree bark pattern.

4 THE SIMPLE LANDSCAPE MINIATURE

A landscape miniature can be done from a sketch made in the field or from a photograph. The painter of miniatures is concerned with landscapes where clear detail is seen. *The Broken Gate* does not have as much detail as it seems to. The main elements are the gate itself and the fence posts. As we go along in this book you will be using more detail in subsequent pictures.

In choosing a subject, make sure it is simple. What is very important about a miniature is that the smaller it is, the more perfect the composition has to be. Horizontal views are not as attractive as those that lead the eye deep into the pictorial space. Therefore, pick a view in which the focal point is in either the foreground or middle ground, with secondary focal points in either the middle ground or background. *The Broken Gate* has the gate as the focal point; it is near the foreground, with the bushes providing additional interest. The trees are mostly in the middle distance; the far trees are, obviously, in the background. The path leads the eye into the field behind and to the trees in the far distance.

MATERIALS

You will need a piece of ivorine slightly larger than the image will be, plus a larger piece of white mat board to provide a dense backing.

You will need the following materials, including two mediums; for "recipe," see page 25.

Matte acetate transfer paper (Saral)

Sables: #000, #0, #1, #2

Da Vinci Series 10 #4

Angular brushes ¼" and ⅛"

Detail mop amd ¼" mop

Grumbacher Oil Painting Medium 1

"Recipe" (Winsor & Newton Liquin and Odorless Thinner, plus poppy oil)

Artists' mineral spirits, or Weber's Turpenoid

Palette When a particular color varies from manufacturer to manufacturer, I name the one that I recommend in the list at left. All alkyd colors so far are made only by Winsor & Newton.

In addition to the paints listed, lay out your watercolor pencils as well.

STAGE 1

Measure the photograph. On a piece of sketch paper, draw a frame. Draw the horizon across the frame.

If you are new to painting in miniature, it will help you to measure the distances in your reference photograph and sketch them in accordingly. For instance, here I measure the width of the gate from the fence post and mark with a dot, then measure from gate to opposite fence post and draw in the post, and so on. Draw in the two thick trees, the two thinner ones next to them, and the grassy center of the pathway. Do not make the pencilwork heavy; it should not show through the paint. Do not draw in the foliage of the trees in the distance, just put a series of little dots where they come out against the sky. With tiny reference dots here and there, put markers for the distant trees.

Eventually you will train your eye and your hand to work on the small scale of the miniature and to render the subject accordingly. Work freehand as much as you can.

View the sketch in a mirror to check for a balance. When you are satisfied with the composition, use a light box, bright window, or transfer paper and transfer your sketch to the ivorine, drawing *lightly* with watercolor pencils that approximate the colors you will be using. If you use a lead pencil or charcoal you may remove the drawing.

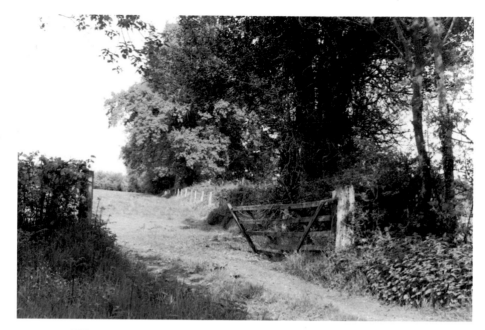

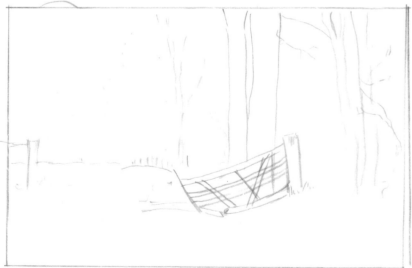

Top: A reference photograph for the following picture, The Broken Gate. *Below: a sketch on ivorine, based on the photo.*

STAGE 2

Underpainting Sky and Trees

Always start by underpainting the broad areas of color. To begin the sky, first dip your ¼" angle brush into the medium, flatten the brush in ultramarine blue, and pull it on the palette surface so that just a tint appears. Now turn the brush over and dip it in cobalt blue, flatten it, and stroke. The colors will mix on the brush.

After a light touch to the towel, pull the angled edge of the brush straight across the sky and over the drawing of the trees. If you do not press too heavily you will not disturb the watercolor pencil. Several swaths of color should fill in the sky almost to the distant tree line. Immediately use a paper towel to rub in the paint, for a soft tint of blue.

With a very small amount of alkyd rose madder, create another tint and apply it in the same way just above the tree line. You may need to add medium to the color.

With the angle brush, follow the same procedures as before with olive green and a touch of ultramarine.

With the slanting edge of the brush stipple in the very distant tree line. Then tap in color, working across the bottom of the tree line in the distance, stopping at the large tree trunks.

Block in the tree trunks and branches when the sky has dried (diluted alkyd takes about half an hour to dry). Flatten your angle brush into alkyd burnt umber, then tip the edge with burnt sienna. Paint in the tree trunks first. A ⅛" angle brush could be used for the smaller tree, if you have problems in using the ¼" brush.

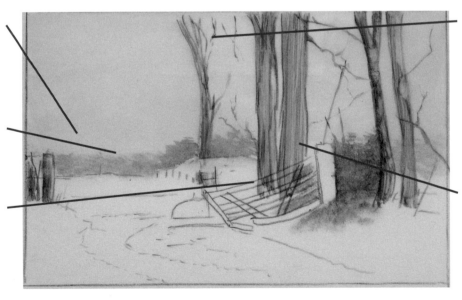

Rub in the rose madder tint above the tree line, working upward into the blue.

Tap gently with the mop to soften and spread the stipples on the skyline.

Stroke the tree color down, crossing through the gate.

For the branches, use "recipe" as your medium on a #000 brush and point it with burnt umber. If you make them too thick, lift paint off along the branches, a little at a time.

You can also lift off color to create bark at this point.

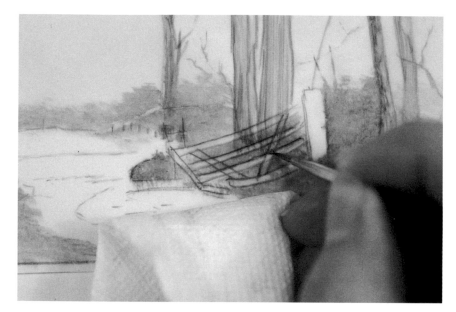

With a #000 sable, lift off the paint you pulled through the gate. This is better than trying to paint around the bars of the gate.

STAGE 3

Re-glaze the sky, now dry, with cobalt blue and ultramarine. This time don't rub it in, but go over it with the blender mop. Use a clean mop to work a little more rose madder into the horizon, gently blending it into the blue, almost imperceptibly.

At this point, you should allow the paint to dry for a couple of hours or more. When you resume, check the surface to see if it needs a gentle scrubbing.

Field and Pathway With a #2 sable, pick up some oil phthalo yellow-green and alkyd sap green. Keep this paint mixture a bit wet. With the point of the brush lay in some pale green across the field in the distance,

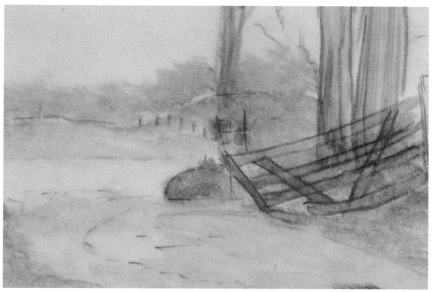

After stippling in the pathway, gently touch your blender mop to the path.

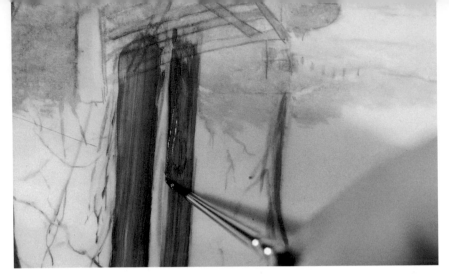

Left: With the painting upside down, it is easier to see where your brush goes and to keep within the edges when deepening the colors of the tree trunks.

Below: Putting in the clouds and the gate.

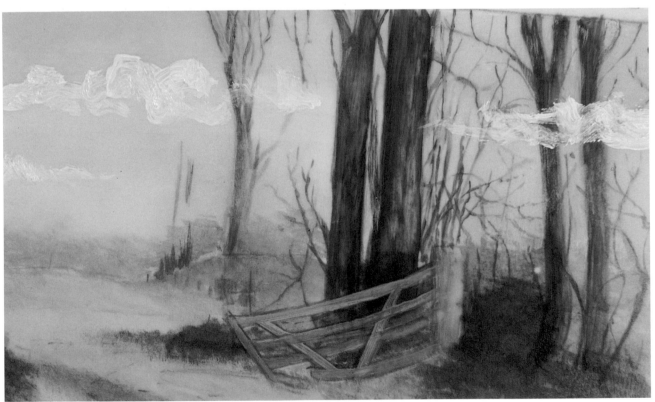

working the paint outward and down so that it meets the path. Tap gently with the blender mop to remove any surplus paint.

Changing to the angle brush, stipple the grass in the foreground in olive green. Stipple the bushes on the right also.

Now pick up some yellow ochre—not too much—and stipple in the path that leads out into the field, blending it with the pale green. To lift off little white specks resembling small stones, use a clean angle brush to tap across the area painted with yellow ochre. (Don't overdo this.)

Clouds Use your #1 sable, and keep it slightly wetter than you do when stippling. Twirl it in alkyd titanium white to put a couple of clouds in the sky. Apply the following technique:

1. Put the point of the brush down at the middle left of the sky, lower the point, and press.

2. Drag, twist, and turn the brush across part of the sky. You will find that some of the paint rolls a little at the edges.

3. With the point of the brush, pull out some of the rolled edge and feather it away from the cloud.

4. Freshly point the brush with medium and pull out more feathers of paint from the main cloud.

5. Tap gently with your blender mop.

Painting the Gate Begin painting the gate with your #0 brush twirled in burnt sienna. Put on just one thin application. Don't put the color on thickly; you can go over it again within the hour.

Use a #2 sable brush to paint in the left fence post lightly with burnt sienna. Follow through while it is wet with some long and short lines of burnt umber.

Now is also a good time to go over the tree trunks again. Deepen the colors, and sharpen up some of the branches with alkyd burnt umber mixed with a little Payne's gray.

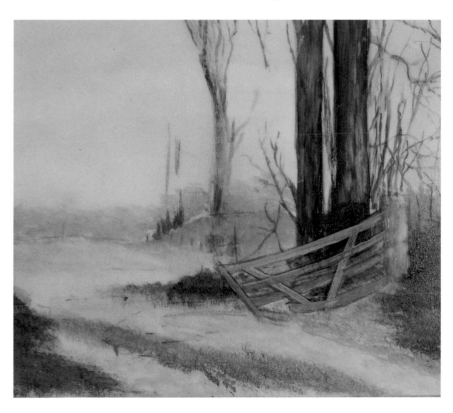

Soften the clouds and lift off the white paint that you put in front of the trees.

STAGE 4

When your tree trunks are dry, do further work on the clouds. Dip your #2 brush in recipe and then in both alkyd and oil titanium white. Place the brush on your clouds, flatten it a bit, and wriggle the brush from side to side. You can paint over the trees and lift off color later as needed. Feather out bits of cloud as you see fit. With the mop, gently touch the cloud. With another clean sable brush, soften the underside of the cloud to make it lighter at the top and slightly shadowed at the bottom.

Now with the brush washed in medium or thinner, lift off the white paint that was pulled across the trees.

If you can break off for a couple of hours, do so at this stage. Oil mixed with alkyd will take longer to dry than alkyd alone.

STAGE 5

Painting the Foliage Using your angle brush, stipple olive green and Payne's gray for the foliage. With the corner of the brush, hang foliage on and around the branches. Fill in the central dark masses of foliage with the flat of the brush. Do not have the brush too wet; you will get better definition with a drier brush.

For thinner foliage isolated against the sky, switch to your #000 brush. With olive green and Payne's gray on the brush, put the point down first and lift away sharply, and you should have a minute leaf. The more heavily you press down, the larger the leaf will be. Stroke very slightly with the brush and you will come up with a tiny, slender leaf. Practice this a bit, for it is essential to make good leaves silhouetted against the sky.

Place dark, tiny leaves in varying heights at the perimeter of the dark stippled areas.

Paint leaves in front of the tree trunks.

Remember to hang leaves on both sides of the branches.

Touch the yellow-green glaze on the field with the mop and fade it into the edge of the path.

Try other brushes and other points, too. The #0 synthetic Da Vinci "Spin" brush can give a surprising variety of leaf shapes. An old, small, synthetic brush can give other variations. Test them out, however; they must be controllable before you apply them to your painting. You do not want to mess up your sky by having to lift off mistakes.

Now scatter small leaves in and out of the branches you put in earlier.

If you have not already painted in some thin stalks and branches around the fence posts, do so, and add tiny leaves to them.

The foliage should become tacky-dry. Then some lighter areas can be put in with lemon yellow mixed with a touch of phthalo yellow-green. Use a synthetic round or the #0 "Spin" brush, and flatten the tip slightly. Tap this color carefully on the dark areas of foliage for some soft green foliage.

Always pay attention to the light in your reference photo, and notice where it is coming from. This scene is lighted from the left and top. Introduce your lighter greens from the left top and side, letting some of the darks show through in places. The dark background will help to show up the greens and give some shape to the leaves. Keep them very tiny, however, and keep looking through your magnifying glass.

Next, add interest to the field by stippling across the area using a #1 brush. Do this with both olive green and sap green. Then use phthalo yellow-green to glaze over the field with a #2 brush. Dilute the color and allow darker areas of grass to show through.

This painting should now be allowed to dry thoroughly overnight, for the oils need a little longer drying time.

STAGE 6

Adding Foliage Detail With the "Spin" or similarly shaped #0 synthetic brush, repeat the process of painting in small leaves with the brush point flattened slightly at the tip. This time dip the brush in "recipe," and mix cadmium yellow, alkyd burnt sienna, and oil titanium white. Practice painting yellow-brown leaves.

Introduce leaves into the foliage at the top and back of the trees, where the light is brightest. The greens underneath will tinge the yellows slightly. Paint leaves over the dark foliage in the distance also.

You are now using oils plus alkyd more frequently, so you should notice the smoother, less draggy feel of the brush. Before you go too far with these, paint in tiny branches showing through the leaves here and there.

You will probably feel "leafed out" by now, so take a break and allow the

painting to dry for a couple of hours or more.

Grasses and Flowers Use your angle brush now with alkyd olive green and phthalo yellow-green to stipple and stroke in grasses on the strip of earth in the middle of the path. With the #000 sable dipped this time in oil olive green and Payne's gray, paint in additional tiny stalks with a few leaves at their bases. Tiny strokes of pale green can be put in against the dark green. Cadmium yellow, phthalo yellow-green, and titanium white will give other variations to the grasses.

For the tiny flowers to the right of the gate, paint the long stalks in pale green using a #000 brush. With oil titanium white and a touch of alkyd rose madder on the tip of the brush, paint the flowers, which can be represented by the very smallest of dots grouped in a circle.

Tiny specks of yellow dandelions can be dotted in the grass, but they must be really tiny and in scale with the picture. Again, always watch the scale very carefully; it is quite easy to paint the flowers too big. The dandelions can be painted as tiny, dark leaf shapes with a minute spark of alkyd lemon yellow.

Light and Shadow Effects If you want to give the background trees a misty effect, dip your #2 sable in

"recipe," then in oil titanium white, and paint thinly all over the edge of the field and far tree line. Turn your mop around and around on it and work the white up over the tree line and into the sky. You should achieve a delightful mistiness.

Study your photograph to check where the shadows are. In general, when using oils and alkyds, shadows on objects are put in as you go along, and shadows cast by objects are laid on last. Here, there are just a few cast shadows on the thinner trees in the foreground. With the technique of

Use sparing applications of lemon yellow with oil titanium white to add sparkle to the trees and grasses.

Leaves that are nearer should be larger than the leaves farther back.

With a #000 or #0 sable brush, mix oil and alkyd titanium white to paint in the fence posts bordering the field. There are also a couple of tiny posts to be put in at the top of the rise of land.

Add leaves to the foreground bush near the gate.

Use sap green and white to put in a few blades of grass in pale green here and there up the center strip

Add color variation to the larger green leaves in the right foreground where the light falls.

thinly applied glazes, these shadows are put in over the detail. Mix some oil rose madder with Payne's gray. Paint in front of the left post, throwing a shadow over some of the flowers (which must be dry).

Go over the gate with a #0 sable. Use medium to dilute burnt sienna and burnt umber. With oil burnt umber mixed with alkyd Payne's gray, darken the broken bottom bar and the right post. Then highlight the gate with some oil titanium white, and then burnt sienna and yellow ochre.

STAGE 7

Allow the painting to dry for at least a week, then varnish it. I recommend Grumbacher Advanced Formula Matte Spray for oil and alkyd paintings. Avoid Damar sprays; they are too harsh to apply to your thin glazes. Place your painting on an easel and spray lightly from a minimum of a foot away across, and then up and down the picture. *Do not saturate the painting.* After ten minutes, spray again, this time getting a little closer to the work. Go across, then up and down. Allow to dry for about fifteen minutes. Check to see if there are any gaps in the coverage. If there are, repeat again. This spray varnish will give an "eggshell" patina.

If you would like a glossier look, spray closer to the painting, going swiftly from top to bottom, then side to side. Immediately lay the painting on a flat surface to allow the varnish to level. Place a box over it to protect it from dust and leave it overnight.

THE BROKEN GATE

The completed painting, shown here actual size.

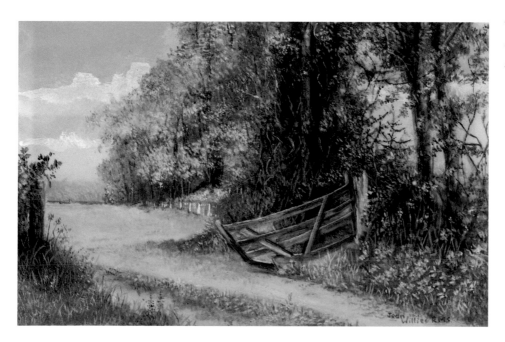

PAINTING A FLORAL IN WATERCOLOR

To paint a sunflower miniature, we'll work in watercolor on ivorine. In addition to the materials you normally use, be sure you have the following:

Ox gall or, if you prefer, gum arabic

Sketch pad or layout paper

Matte acetate

Red and gray Saral transfer paper

Brushes

Sables #000, #0, #1, #2, #3, #4; optional sable: #00000

Silver kolinsky 7000S

Silver Golden Natural 2020S

Synthetic angle ¼" and ½"

Synthetic filbert ¼"

Blender mop and mini-mop

Use distilled water for your watercolor paintings. I recommend that you have white gouache for some final touches. Also you will need the following watercolor pencils: Medium yellow, cadmium yellow deep, burnt sienna, brown, burnt umber, cadmium red, blue-violet, leaf green, olive green, and blue-gray.

A small spare piece of ivorine for practice is always useful. Remember to prepare ivorine by washing it in warm detergent water, and giving it a slight sanding with a clean scrubber that has not been used for sanding oils. You will also need a clean piece of silk.

Before you begin, mix the medium you will need, making it 25 percent ox gall and 75 percent distilled water.

STAGE 1

Some people get quite "hung-up" trying to draw a vase. Here is an easy way to get the sides even. Use a piece of grid paper, to keep your drawing perpendicular, and a circle template—or, failing that, a quarter. Measure the frame you want to use, and draw a vertical line down the left side of the drawn frame. (My frame measured 3½" x 4½".)

Place the circle just to the right of the line. Measure the center of the circle and draw a dividing line down through it. Then add an ellipse at the bottom, making sure that each side is equal. Draw narrower ellipses and connect them with a tube for the neck of the vase. The handle can

then be sketched in.

The flower centers should be drawn in a balanced, roughly triangular arrangement. Adding a flower at the bottom of the vase will give some strength at the base. Draw in the low horizon line.

Make a rough count of the petals in the photograph, and draw these in, tapering them off as they reach the center. Do not draw the petals exactly alike. You will notice that some details in the photograph are eliminated. Also shadows are not drawn in; they will be added last with the brush.

Transfer the drawing to the ivorine using yellow watercolor pencil for the petals, dark green for the leaves, and gray for the vase.

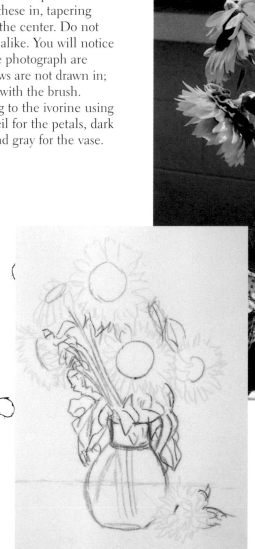

Above: Reference photograph of sunflowers.

Left: The sketch transferred to ivorine using watercolor pencils.

A drawing of the vase on grid paper.

STAGE 2

Underpainting by Stippling With an angle brush, either the ½" or the ¼", pull a stroke from thinly diluted ultramarine on your palette. Flatten the brush into the paint, and pull it across your test piece of ivorine. If it comes out in a light, transparent tint, brush across the picture and around the flowers, blotting with a piece of paper towel as you go. This will dry immediately. Use a smaller brush to carry paint into the edges of the drawing. Avoid picking up any yellow from the watercolor pencil lines.

Repeat this step, flattening both sides of the brush into the color.

Practicing on spare ivorine.

Using the very edge of the angle, do a test stipple, then stipple up, down, and across the picture, without putting more paint on the brush.

Flatten a smaller nylon brush— the Silver Golden Natural 2020S is a good choice—in both ultramarine and Payne's gray. Stipple over your first layer of color.

With a transparent, not-too-wet yellow ochre, lightly paint the table-top, trying not to disturb the pencil lines.

Allow your painting to dry thoroughly, then carefully repeat the stippling process. This second stipple should be allowed to dry well also, before you attempt the next, final one.

A dark background like this one can be more difficult than the rest of the painting, so consider these suggestions:

1. If your brush is too wet and you inadvertently lift a patch of color, take your #000 sable, twirl it to a point in the colors, and see if you can repair the patch by stippling in little dots.

2. If you get some stipple build-up of pigment, rub gently with a clean scrubber.

3. To intensify color more, paint tiny lines and cross-hatching with the point of the #000 brush.

4. If you get frustrated, settle for a lighter tone.

Carefully repeat the background stipple. All mottled and stippled backgrounds look nice. Practice will increase your ability to darken the color evenly.

Light is coming from the left of the picture, so apply the darker stipple to the right side first, then continue down to the bottom using a #0 sable.

STAGE 3

At this stage you could work on the tabletop. Practice your strokes on your spare ivorine.

Flower Centers Twirl the brush in burnt sienna and lightly work the point, allowing it to be slightly wet, over the centers of the sunflowers. By the time you have done the flower at the base of the vase, the centers will be dry enough to go over again. This time, mix burnt umber with brown madder, and do not dilute it much. Go over the flower centers with a series of tiny dots, working in a circle and finishing at the center. If necessary, repeat this when the centers are thoroughly dry. Then, with your piece of silk, polish well to harden the surface of the centers. This will give you a better chance to paint detail later.

Putting in Yellows and Greens Lift off a line for the stalk and a little leaf for the flower in the front and you'll be ready to begin the flower petals.

Make a light tint of lemon yellow, and lightly paint in each petal of the sunflower with a #000 brush. To get a complete petal shape in one movement, put the point of the brush down at the top of each petal, press down lightly, stroke the petal shape, and lift the brush away. Take your time; turning the picture as you go helps, so that you don't paint blind. Continue all around the heads of the top two flowers.

Brush a creamy mixture of burnt sienna and your ox gall–distilled water medium into the tabletop with a #2 brush.

Using watercolor pencil and a ruler you can divide the table into boards, if desired—just draw lightly across.

Paint across in lines to get the effect of wood grain.

Paint some petals with slightly more paint using cadmium yellow.

With a creamy mixture of burnt sienna and sap green, put in fine lines for the stalks and some leaves. For the best flow, use some ox gall–water medium.

Using diluted olive green, and with the brush not too wet, paint in the leaves.

Using a #1 brush, add some lemon yellow to the light areas of the leaves.

With burnt sienna and cadmium yellow you can put dark accents on the petals and paint the smaller petals. Lift-off technique will give you a very fine edge on small petals inside the ring of larger petals. Some of the lemon yellow will come off, but not all.

Further Stippling Go over the background of the picture again with an angle brush, and stipple in Payne's gray and a little burnt umber in the darkest parts. With a small brush, put in the ultramarine–Payne's gray underpainting color between the stems. Paint in and darken the background between the petals, as needed.

A slightly damp mop moved over the background and tapped very lightly will help to smooth out the stippling if it begins to look too heavy. If any paint goes over into the leaves, gently lift off, back to the line of the leaf.

Study the photo's top two flowers (page 59) to see where the petals darken. Mix burnt sienna and cadmium yellow and paint in these darks with a #000 brush. When using a tiny brush, water is apt to run down onto the picture, so take care.

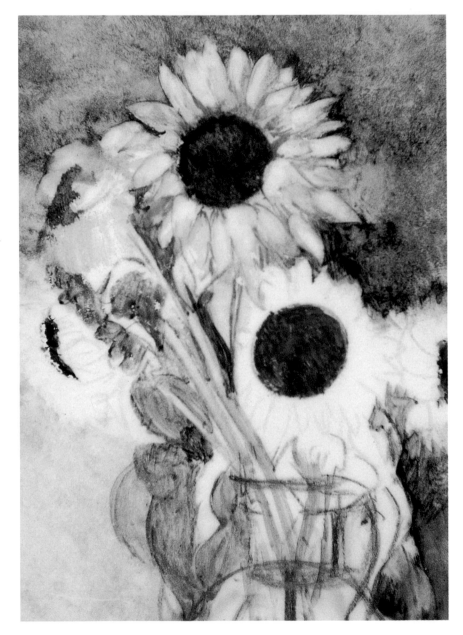

STAGE 4

After drying and polishing again, twirl your #000 brush in titanium white and a little cadmium yellow. Lighten some of the petals on all the flowers, including the one on the table.

Stipple in pollen-filled stamens in the dark centers and sides of the flowers, using little dots and lines of white and lemon yellow. Don't go too quickly. Allow the surface to be quite dry before adding detail to detail.

Twirl the brush in olive green and go over the darker leaves again. Allow the paint to dry. On the lighter leaves, paint in a little more lemon yellow. Use the point of the brush and work in little strokes, working downwards on the leaf. Blot gently with a paper towel.

Return to the flowers. Each head should be painted as the first two were. The lower flowers will need more orange inside the cupped petals. Some burnt sienna and a little cadmium red with the yellow will give a nice glow. The inside of the flower heads, especially those on the shadowed side, could be tapped in with little dots and a few lifted-off lines.

Add burnt sienna to your white–yellow, and paint tiny stamens at the edges of the flower centers. Separate them here and there with a few dark brown strokes. For sparkles put in the tiniest white–yellow dots you can manage.

With burnt sienna, lightly paint veins on the light sides of the leaves. Refine the lines by using the ox gall medium to lift off part of your painted line.

Add olive green on the darker side of the stalks, and sap green and white in a fine line down the left side. Delicately touch the area between the light and dark of the stalk with a barely damp #0 brush to soften the blending colors.

Gently work over the olive green in the darkest areas of the leaves with Payne's gray.

Lift off the curling edge of the leaves with a slightly damp brush. Paint the curl with titanium white and lemon yellow.

Stalks are painted into the vase with olive green for the darker ones, and olive plus sap green and lemon yellow the lighter ones. Give them a fuzziness by tapping with a mop.

STAGE 5

Glass Vase Draw carefully with the point of a fine brush as with the tip of a pen to outline the vase in a little Payne's gray and ultramarine.

Twirl the brush in brown madder. Go over your pencil lines for the vase, making a double line at the bottom of the neck of the vase and another two lines for the band near the top. Carefully paint the slanting lines from the top band curving slightly down to the bottom band. Space these about 1/16" apart and try to keep them evenly spaced. Do not go over any line twice. When you have completed this, paint the lines the other way with slightly curved diagonals. You may find it helpful to turn the picture around. Using burnt sienna only, carefully paint in the wider bands, top and bottom, and also the handle.

Now, within the vase, pull a damp brush down the left-hand side to take off some of the top glaze of the tabletop, leaving the earlier glaze showing. The illusion of water in the vase is enhanced. (If you take off too much, a little diluted burnt sienna can be glazed in again. Ivorine will take many lift-offs, so you can do this several times till it comes out right.)

The stalks in the water can have a light thin line lifted off here and there. A swift tap of the mop will soften and spread the lift-off, increasing the watery effect.

Before continuing, you must let the paint harden at least an hour, and then polish. Then, on the left side of the vase, tap in a Chinese white highlight with the point of the brush. This will have a semi-transparent, cloudy effect. Add some titanium white to it and paint the rim of the vase, not all the way around but just between the leaves.

Mix a little ultramarine with olive green and lightly put a little shadow on the vase under the left leaf, which hangs down. Barely touching the surface of the ivorine, use linear or tapping strokes.

For the exacting lines of the vase you will need to frequently reshape your brush, refresh it in medium, and twirl it to a point. If you do not, and run out of paint, you will get uneven lines. By lifting off, you will create the water line in the vase and a line at the top of the vase, to indicate the rim.

STAGE 6

Finishing Details Add some burnt umber to ultramarine and olive green, and paint in a shadow at the base and to the right of the vase, and also under the flower at the base.

Dip your #0 brush in brown madder and put in the top and bottom of the lattice pattern on the neck of the vase. With a fine brush such as a 7000S, carefully paint the lattice lines. Mix some burnt sienna with some titanium white to a creamy consistency and lightly stroke in highlights on the left of the latticework. Do not blot, or touch twice; these strokes will sink in. When they do, repeat until the highlight sparkles.

For a reflection of the flower in the vase, dip a #1 brush in medium and do not dry it, but twirl it in cadmium yellow and a touch of burnt umber. Put a tiny drop on the glass where the flower rests. This color should spread and settle.

Some of the petals of the flowers can be further lightened with a touch of white gouache mixed with cadmium yellow. It is unwise to use the white gouache on its own, for it has a chalky look and does not appear to blend in with the watercolors. If you find that the gouache "shouts" at you, sand the area gently with your scrubber, and touch it up with titanium white.

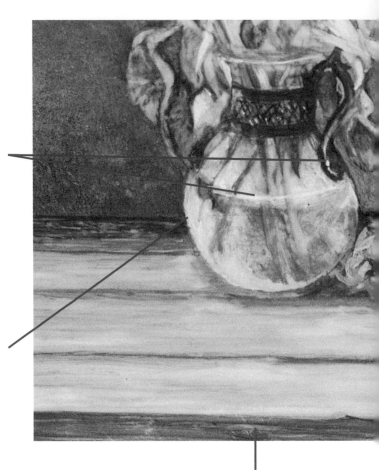

Dip the brush in ox gall medium, roll to a point in titanium white, and lightly draw in a highlight on the water line. Put in similar highlights on the base of the handle where the light would hit it.

Very tiny drops of Chinese white can be dropped on the glass.

Burnt umber and burnt sienna are used for the edge. Twirl the brush in one color and tip the point with the other.

Add burnt sienna and burnt umber to the back of the table.

A dark green leaf can be added to the flower at the base. Paint it first in olive green and Payne's gray. Lift off the lights and lightly paint in some lemon yellow or cadmium yellow.

With a burnt umber watercolor pencil, strengthen the lines between the boards and trim the edge of the table.

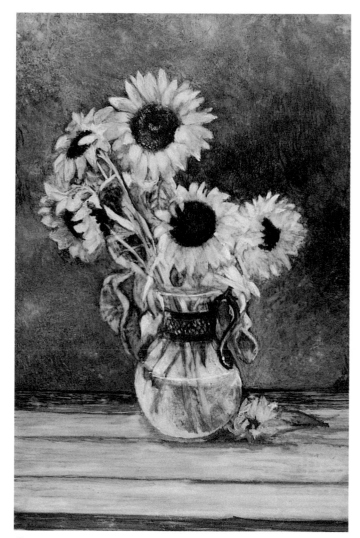

SUNFLOWERS

This watercolor, shown actual size, must be protected behind glass and have a mat.

6 PAINTING A LANDSCAPE ON VELLUM

PALETTE

Titanium white (gouache and
 watercolor)
Lemon yellow
Cadmium yellow
Naples yellow
Gamboge
Yellow ochre
Burnt sienna
Raw sienna
Burnt umber
Brown madder
Light red oxide
Cadmium red
Venetian red
Indian red
Violet
Ultramarine
Phthalocyanine blue
Terre verte
Olive green
Spring green
Sap green
Payne's gray
Davy's gray

This painting is developed from a sketch I did many years ago of some old English cottages. These cottages have disappeared by now; therefore I have no colors to go by, just my memory. I painted on vellum in transparent and gouache watercolors. By using these media, we are painting the most traditional of miniatures, from a time when little scenes were incorporated into capital letters, helping to tell a story and embellishing calligraphy.

As mentioned earlier, one thing you can do on vellum which you cannot do on paper is put on many layers of color. Remember, after all, that the special technique of the miniature is to paint mostly in thin glazes of color, one over the other, so that the light reflecting from the white ground lends the work a special glow. However, you must take care: vellum will wrinkle if it gets *too* wet.

MATERIALS
Lay out the following brushes:

Sables: #000, #2, #3, and #4

Da Vinci 10-zero brush

Silver kolinsky 7000S

¼" synthetic angle brush

Da Vinci "Spin" #1 brush

Two mini-mops

You also need to keep some paper towel or a soft rag for blotting and a piece of silk for burnishing.

I recommend that you put each of your colors onto the palette only when you begin to need them. That way, they will not lose freshness or need to be reconstituted. You will need gouache as well as watercolor titanium white.

In preparing your palette (left), keep aside the white gouache, which will be used later. The watercolor will do a certain amount of sinking in, and the highlights will have to be built up with gouache.

Along with distilled water, have ready a medium mixed from distilled water and 25 percent or less ox gall. Ox gall medium is mainly to be used when you want to delay drying time or point the brush to paint fine lines.

PRACTICE PAINTING: THATCHED ROOFS

We'll begin by practice-painting the thatched roofs. Do this practice on plate bristol or a smooth hot-pressed piece of card instead of vellum, which is too expensive to use for practice.

Sketch a small roof with a #000 brush twirled to a point in yellow ochre. Tip the brush with a little burnt sienna and paint it on the roof. Immediately, with a mop, lightly tap the roof to blend and soften the colors, leaving just an impression of streaks angled down the roof.

With your brush twirled to a point in burnt umber, and using your magnifying glass, develop the roof as illustrated below:

1. Paint in three lines of stitching. Work a little over the top of the roof to darken it, and give it a sharp edge.

2. Paint in a few streaks. Then switch to a very fine brush such as the Silver 7000S. It must be just sufficiently wetted using the ox gall–water medium. With burnt umber draw three fine parallel lines, then crisscross diagonal lines between them, making two lattice patterns.

3. Add lines of burnt umber with a little Payne's gray added. With the 7000S or a #3 sable (Maestro is good), use titanium white in *both* gouache and watercolor. Paint in some cross-hatching, giving a sparkle to the thatch.

4. Last, with burnt umber, add the ornamental stitching at the top.

Practice paintings for the cottages' thatched roofs.

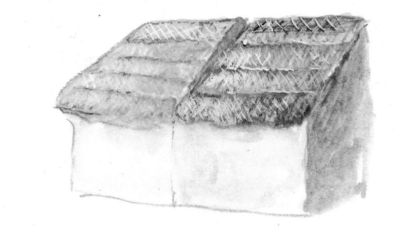

For additional practice for thatched roofs, work with paler colors using cadmium yellow as your initial glaze. The impression of bright light is achieved with softer lines and more hatching in cadmium yellow and gamboge mixed with white. Other colors can be experimented with: brown madder and ultramarine for the darks, burnt sienna for a warmer straw color.

PRACTICE PAINTING: FLOWERS AND GRASSES

You will use essentially the same techniques you used for grass in oils and alkyds.

1. First, with your #3 brush, paint a light wash with sap green and a little lemon yellow. Allow the color to dry patchily, and polish it with your silk to harden the color.

2. With the angle brush, use olive green to stipple, working until the paint gets too dry. Repeat the stipple as necessary.

3. With a fine sable brush, put in some sap green and then olive green, pulling up some strokes for grasses. Turning the picture upside down will help you to get fine grasses.

4. Using the 7000S or #000 brush, add tiny dots for the dark leaves.

5. With cadmium yellow, dot in some tiny flowers.

6. Turn the painting upside down and draw fine lines from the bank downward in olive green for the stalks of the phlox. (You can use any tall flower you wish for this practice, but aim for accuracy.)

7. To make the leaves, dip the #1 brush in the medium to delay drying and give flow. Twirl it in sap green and put a touch of burnt sienna at the tip. Make long and short drooping leaves which are lightly browning at the tip.

8. Twirl the 7000S brush in cadmium red, then tip in brown madder to dot in some tiny five-petalled flowers at the base of the flowers, close to the stalks.

9. With the cadmium red mixed with a touch of cadmium yellow, add some lighter flowers, as shown in the illustration.

10. Add a few strokes for small leaves at the base of the flower, using olive green. Put in other grasses and weeds, working as delicately as you can.

Practice painting the roses for this picture, too. Make a creamy mixture of your favorite color on the palette, lay the brush on its side in this, and twirl, *lifting away* as you do so. The brush is then filled with color, and yet has a fine point. Placing this point down, pressing slightly, and twirling will produce a rose.

Practice for flowers and grasses. If you can, make your dots tiny circles to form the flowers, but keep them the size of a pinhole—quite a challenge. Using medium will help.

STAGE 1

Sketch the scene on a sketch pad, not on the vellum, for erasures will dirty the surface and are not easily removed.

If you are not sure of your perspective, and to keep your lines perpendicular, use grid paper and a ruler to draw the lines of the roofs and roadway. First draw the frame on the grid paper (the same size as the picture shown here). Measure the distances from the frame to the roof lines at both ends and mark position points on the grid paper.

Do the same for the bottom line of the thatch, the lines of the bottoms of the houses, and the pathway. With your straightedge, draw light pencil lines for the roofs, the thatch, and so on.

Draw a straight line down for the end wall of the row of cottages. Similarly, measure (1) from the frame to the roofs going across the end of the street. Measure (2) from top of roof to bottom of thatch, then (3) from bottom of thatch to pathway. Ruling lightly across will give you three lines in the background.

Similarly, measuring the widths of the road at front and back will give you the lines of the road as it narrows and give depth to your sketch.

Now, with your grid lines helping you, you should be able to sketch in the other details. Trace in further

reference points if necessary, but try to do as much as you can freehand.

Transfer your final drawing; draw *lightly* on the vellum with a yellow ochre watercolor pencil for most of this drawing.

Finally, place a little arrow outside the picture on the left to indicate where the light is coming from. You would be surprised how often even the masters have forgotten the light direction and placed shadows in the wrong places. The arrow will be a constant reminder.

Position points were the basis for this outline sketch.

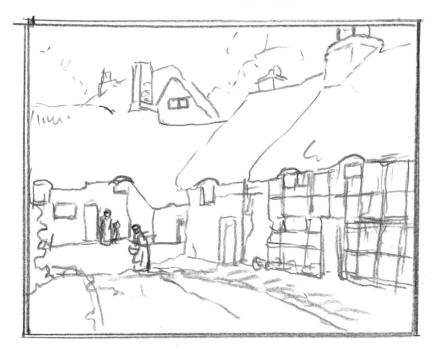

My final outline sketch for English Cottages.

STAGE 2

Mount the vellum on acid-free foam-core board. Draw the frame on the board, and use spray-on mounting glue to affix the vellum. Make sure your piece of vellum is well removed from the area when you spray the glue. With a spatula, pull the glue out to the sides before you drop it onto the board. Position it gently inside the frame area. Cover it with a paper towel and press it down firmly to ensure that the vellum is perfectly flat on the board. When the painting is finished, the spare foam-core can be trimmed away from the picture. Allow the glue to dry thoroughly.

STAGE 3

Underpainting Begin the painting with a wash of ultramarine for the sky, using a #3 brush. Put in each horizontal wash at a time and blot as you go. Before the paint is dry, swish around a soft mop to pull the lines of paint together.

Dip the #3 brush in ox gall–water medium and dry slightly. Then go back over the sky and lift out some clouds. If you want whiter clouds, use some titanium white lightly diluted and whisked around with the blender brush. Then blot.

With diluted yellow ochre, brush in a thin wash for the houses, roofs, and road. Stay within the line of yellow ochre pencil, for if you go

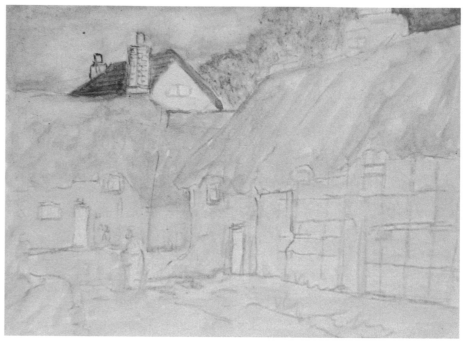

Putting in the layers of underpainting.

over the line the pencil will blend.

As you block in the thatched roofs, pull color downward to the base of the thatch. The more varied the lines, the better. Then come back down with some distilled water on the brush and lift off some of the paint, always pulling down toward the edge of the thatch.

With diluted burnt sienna on a pointed #1 or #2 sable, paint a wash on the roof of the house in the background.

Dilute violet mixed with a little terre verte for a soft gray-green. With a small blender which has been flattened on both sides in the color, gently tap in the distant trees.

Use your #0 brush to lightly paint diluted Naples yellow over the house with the red-brown roof. Don't forget to blot. Paint Naples yellow carefully on the chimney pots.

Allow the paint to dry thoroughly for an hour at least. Then polish with your piece of silk.

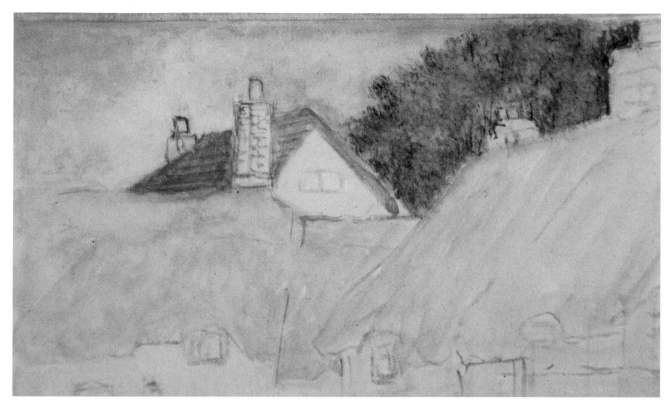

The second layering of color can begin. The front of the house in the background is brightened up here with a thin layer of gouache white with a touch of Naples yellow.

With a little gouache diluted in medium, the sky can be lightened and the clouds enhanced. Do not, however, fall into the trap of putting in thicker paint for clouds, for they will appear rough and chalky. Keep blotting to get a soft effect.

In the treetops, stipple with raw sienna, tipped with yellow ochre, and here and there a touch of Indian red. Allow some of the pale green to show through. Use a damp ¼" angle brush to gently tap down on the foliage, giving a soft effect. When the foliage is well dried, rub firmly again with the silk. You should now be able to come in with spring green mixed with white and lemon, and with a fine brush tap in dozens of tiny dots to put sunlight on the leaves and add the still-green leaves.

Here I have decided to have the trees just beginning to turn to autumn colors, soft yellows, browns, and beautiful deep coppers. Tap in additional color and blot immediately to get a patchy look. Create lots of little patches; if you use the brush too wet, they will be big and blotchy.

Paint the bricks in the chimney of the background house with the brush, or draw them with watercolor pencil.

The front of the house can have the laths drawn in with a dark brown watercolor pencil, or painted in with burnt umber mixed with burnt sienna.

For the plaster between the laths, mix titanium white gouache to a creamy consistency. Let it look slightly rough.

Mix Naples yellow with watercolor titanium white into a creamy consistency with an old brush, then use a kolinsky sable for the chimney pots.

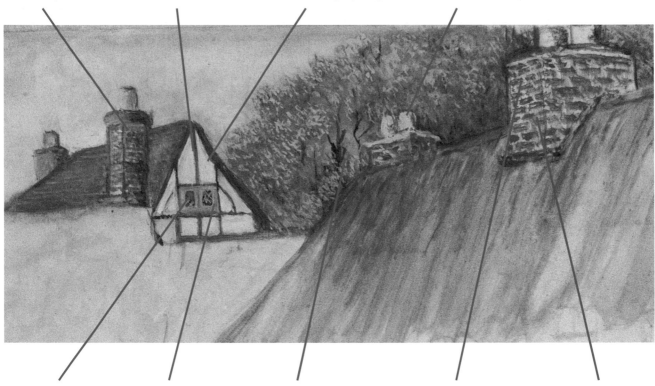

Paint in the tiny windows with ultramarine mixed with a little Payne's gray.

Use burnt sienna and watercolor titanium white for the lines around the windows. Three taps down each side of the windows should do it.

Draw in the tree trunks and branches using a Da Vinci 10-zero brush and burnt umber, with a darkening touch of Davy's gray at the tip.

With your 10-zero brush, paint the bricks on the chimneys. Work a little medium into burnt sienna, burnt umber, and Venetian red and vary the colors by using two of the three colors at a time.

On the light side of the chimneys, titanium white gouache is used between the bricks.

STAGE 5

Mix a little brown madder with some violet, and deepen the bricks on the shadowed side of the chimneys. A dilution of the same shadow color should be lightly glazed in on the shadowed side of the chimneys and under the eaves of the distant house.

Thatched Roof Now, with the #2 brush, dilute burnt umber and stroke in the thatch of the right-hand cottage in lots of small lines. Stroke downward all the time. Where the light from the left falls, you could lift off color, exposing the yellow ochre underneath.

With a less diluted burnt umber draw in the stitching of the thatch. The lines are broken and uneven following the curve of the thatch over the windows. Lay in some dark paint under the eaves of the roof.

Keeping your brush tipped with burnt sienna, paint in some long and short lines down the thatch, and let some of them blend with the color underneath. Go over the thatch on the rear cottages, too, pulling down uneven lines of color. Tap some of these lines gently with a slightly damp mop.

Deepening colors and adding detail to the cottages.

Windows While this is drying, go back to the windows in the rear house, for these need to have a lattice over them. Use the 7000S brush for its fine point. Dip your brush in the ox gall–water medium—just enough to deposit some in the watercolor titanium white. Looking through the magnifying glass, draw three fine lines diagonally across each window.

If you cannot manage three, then paint two, the brush point just barely touching the blue window. Holding your breath helps. Using the same technique, draw the lines diagonally in the opposite direction.

If, when you have done, you don't feel they have come out well, lift them off, repaint the blue, and try again. The vellum is good-natured and will take several lift-offs.

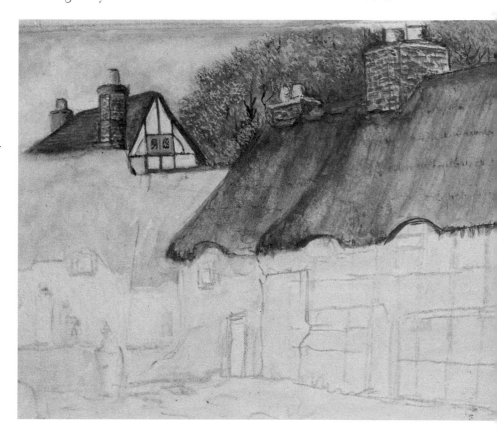

STAGE 6

Sunlight Colors Mix some gamboge and titanium white gouache to a creamy consistency with a sable brush and distilled water. Put in some light strokes of this on the thatched houses at the back, stroking it in between the cadmium yellow and burnt sienna you had put in previously. Catch the top of the thatched roof particularly, where the light is hitting, and where the thatch curves over the doorway.

Remember, as you paint: A gentle tap down with a slightly damp mop will soften your strokes, causing them to blend a little with the color underneath.

The roof on the right of the painting should be lightened. With Chinese white and raw sienna, vary the color of the thatch, painting in tiny lines here and there where the light hits. *All these layers should be as thin as possible.*

The sunny side of the chimney should be lightened. Glaze a thin white over the sunlit bricks.

You can further brighten the foliage by adding a number of tiny sparkles of lemon yellow mixed with gouache titanium white. Do this very lightly.

Terre verte with white here and there will give accents of a less-dried straw in the foreground roof.

With ultramarine, terre verte, and a touch of Payne's gray, paint the shadowed areas on the roof, especially the dip of the thatch between the windows.

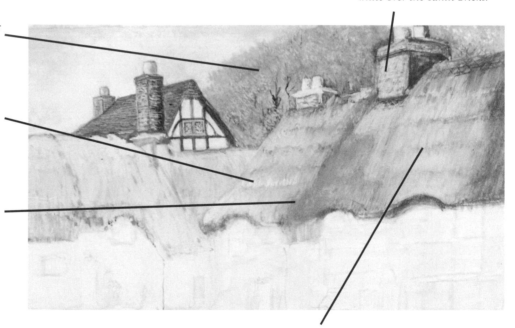

Strengthen the lines of stitching with a mixture of burnt umber and burnt sienna on all the roofs.

STAGE 7

Cottage Walls Using a ruler and burnt umber watercolor pencil, you can now draw in the laths, following your earlier lines. (If your hand wobbles a bit, the pencil line underneath will help to disguise it!)

Next, start painting the small bricks which are exposed as old plaster drops off the cottage walls. Use a very fine brush such as a #000. Twirl the brush in burnt sienna for some, burnt umber for others, and in gamboge and brown madder for still others.

Stones Notice that there is an alleyway between the cottages. Mix some ultramarine with brown madder, dilute with medium, and glaze in the shadow in the alley.

Outline the stone at the corner of the far right-hand cottage in burnt umber. The stones and edges of the walkways should be painted with burnt umber and ultramarine mixed to a charcoal-gray. With a small sable brush, draw a broken line along the edges in burnt umber (see the illustration on the following page).

Shadows Let the watercolor dry. It will be particularly important to harden the paint over which you will glaze shadows, so burnish it with the silk. The color should then glaze very well.

Put in the shadows with glazes, always remembering to blot the color quickly. Use ultramarine and brown madder with a touch of Payne's gray to glide over the areas under the eaves.

For the paler shadows under the roof of the distant cottages, mix rose madder, terre verte, and ultramarine. These shadows are cool and counter the warmth of the browns and golds

In painting the bricks, vary the colors but maintain a reddish tone.

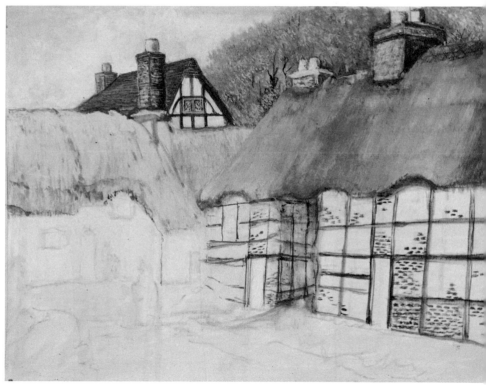

The bricks have been added all along the right row of cottages, and are smaller the farther away they are.

Add a little Payne's gray
to ultramarine for the
cottage windows.

For some final "thatch work," put some
lines of white gouache with a 7000S or
#000 brush in lines. Crisscross straw at
the lightest parts of the thatch.

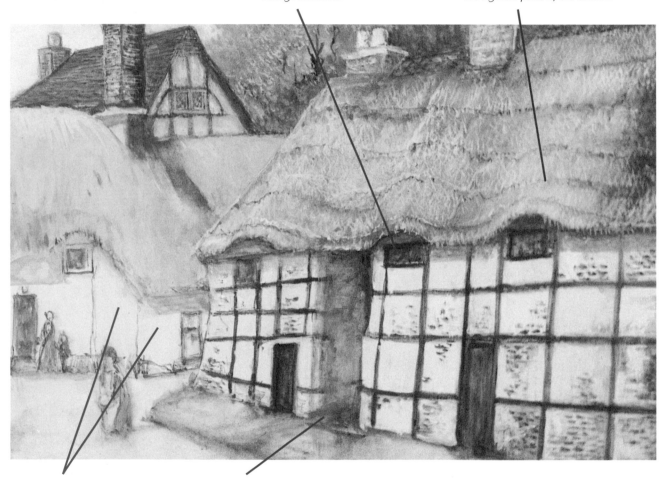

With the palest dilution of terre
verte and ultramarine, glaze over the
protruding wall of the rear cottage.

Darken the walkway at the beginning
of the alley by glazing a mixture of
brown madder and a little ultramarine.

in the picture. This color could also be glazed in for the blue door of the first cottage and for other shadows: on the thatch of the front cottage, on the chimney's thrown shadow on the rear cottage, and at the top of the gable on the far house.

Beginning the Figures Next, with burnt umber, go over your pencil lines for the figure crossing the street. Here are some steps to follow:

1. Twirl a #000 sable to a point in ultramarine and paint in the blue dress of the woman.

2. With watercolor titanium white, paint her apron.

3. Paint her hair in burnt umber tipped with ultramarine.

4. A dilution of light red oxide, nearly dried on the brush and put in with tiny dots, will do the hand and face.

5. Minute dots of burnt umber will do for the eyes, nose, and mouth.

Hold your breath for the placement of each dot. If you don't succeed, clean the brush, lift the dots off, then try again when it is dry—maybe on another day!

The figures at the rear are even smaller. I painted the woman's dress in yellow, and her shawl and the girl in brown. All this work was done in the very tiniest of dots linked to each other. Patience is needed.

Other Details Go back to the right-hand cottages and, with some white gouache, dot in some broken plaster, where the bricks show through. The gouache, drier and rougher looking than watercolor, can represent the powdery plaster perfectly. But don't overdo this effect. If it appears *too* scratchy, wait until it's dry and, after buffing, glaze over the gouache with some titanium or Chinese white watercolor diluted in medium; this will soften it.

STAGE 8

More Shadows Let the picture rest overnight, then buff it. Using your shadow color of terre verte, rose madder, and ultramarine, draw in a fine line of shadow to separate the plaster from the brickwork. Draw the line only here and there where light would cause a shadow.

With an old brush, mix violet, terre verte, and a touch of Payne's gray, blending evenly with medium to make it transparent and not too dark. With your #3 brush lightly touching the walkway, glaze the shadows, including those across the street and behind the figure of the woman.

Note that shadows are darker nearer the object; the farther away they go, the paler they are.

Note that the laths on the side wall of the alley, painted in burnt umber, can be seen through the shadow. If yours cannot be seen, repaint them, allow them to dry thoroughly, then thinly glaze the shadow again in terre verte plus a little brown madder and ultramarine.

Flowers Use your "Spin" #1 brush on both sides in olive green to stipple in the base of a small garden area of the rear cottages. Go around and over the brown fence you have put in, for this was only for a guideline. Add fresh color, spring green and titanium white, over the olive.

When this is thoroughly dry, paint the flowers and then repaint the fence with a #000 brush. Carefully paint in the olive green for the hollyhock stalks on the right and the clematis vine and roses climbing the left wall. Of course, you could paint in any flowers you prefer, but be careful not to upset the color balance—which is important in a tiny picture—by bringing in too violent a color. Never paint *undiluted* red flowers in a distant area, for they will seem to come toward the eye. One way to check that your painting is in balance is to view it steadily with both eyes through your magnifying glass. The colors which are too strong will appear to be hanging in front of your nose, almost in midair. They need to be muted.

Above the door, the roses are in various colors, from pale lemon and pink to white. Put in solid-color roses,

The woman's basket, filled in with burnt sienna and burnt umber, is offset with white gouache in the apron.

Each door has a little doorstep. This can be painted in with the tip of your smallest brush in a mixture of Payne's gray and white.

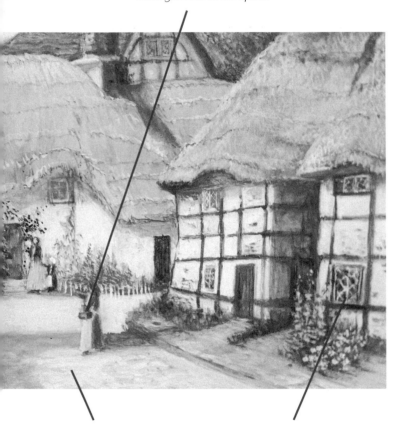

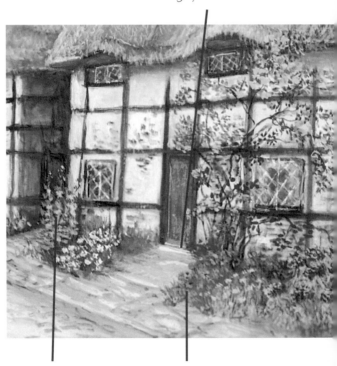

With yellow ochre and a touch of burnt umber, draw the stones in the road, larger and wider at the front, getting smaller at the end of the street.

The lattice of the windows is done with a creamy solution of watercolor titanium white with one of your smallest sables. If your lines stray, trim them down with dark blue, rather than lifting them off.

With a pink mixed from cadmium red and titanium white, paint in the hollyhocks (five petals in a circle).

To the front right of the cottage the daisies are brighter: cadmium yellow mixed with burnt sienna. Use brown madder for the centers.

and also try tipping the brush in one color, then a different color. Gently twirl it on the painting close to the climbing stalks and leaves. Clean the brush and repeat with a variation—say, the lighter color first and deeper color last.

Stipple in the grass in front of the right-hand cottages with olive green, as you did for the first garden. Turn the painting upside down and scatter tiny white and yellow flowers in the grass.

Don't make the mistake of painting the flowers all the same size and in lines. Skimping on essential detail, just because the painting is small, is an error, because a miniature painting will often be enjoyed through a magnifying glass. Therefore, paint the five-petalled flowers in with five petals, put in the centers, and when one flower hangs over another, thus causing shadow, put that shadow in.

STAGE 9

The foliage on the left has now to be painted in, first with olive green and Payne's gray, then with spring green, lemon yellow, and white daintily stippled on it. Grass and lighter green foliage has been stippled in just under the darker leaves.

Final touches will include any strengthening of colors or additions of highlights or shadows that you feel necessary. A touch of violet could be added to ultramarine and glazed as a shadow across the lattices just under the eaves. But be careful: keep the violet to just a touch, or the shadow color of the piece will look artificial.

Place the painting upright, stand back, and look at it critically. Check that all shadows are opposite the light source and that the light along the road crossing the back of the picture is good. When you are satisfied, sign the painting, and don't be tempted to go back and alter it.

A final caution: Watercolor on vellum should never be sprayed with varnish.

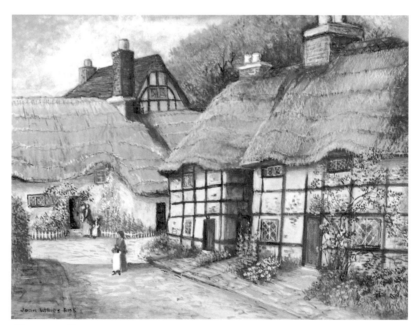

ENGLISH COTTAGES

The completed painting, shown actual size.

7 PAINTING A STILL LIFE ON IVORINE

For this painting of a dish of cherries we will use acrylics as transparent paints, like watercolors. The ivorine ground reflects a lot of broken light rays back from its crystalline surface, and through the transparent layers of color painted on it. We'll also use opaque white to reflect light directly and through transparent color laid over it. Thus, in this picture we are playing with both kinds of light. You will see that by laying opaque white over some of the cherries, and then glazing over them with a bright red, they are invested with a glowing light.

MATERIALS

I primarily used the transparent liquid Rotring colors listed here. If you cannot find the red I have used, cadmium red or Winsor red will approximate that made by Rotring.

You should use distilled water for diluting the acrylic paint. To retard the drying of this fast-drying medium, use a retarder like Rotring Transparent Acrylic Retarder.

Also lay by a watercolor pencil in yellow ochre, and all the brushes, paper towels, and other materials you have used in the previous paintings.

I composed this still life so that the colors surrounding the center of interest would mainly be cool, to counter the warmth of the table, board, and cherries. The lighting was done with blue floodlights to emphasize the shadows.

STAGE 1

On your sketch pad, measure and draw a frame, and with a ruler draw the edge of the table and the cutting board. A faint "horizon" line will help you keep the back of the table and board straight, though this will mostly disappear into the shadows. Draw light lines for the major drapery folds on either side of the plate. Note the slope of the end of the board. Note, too, that the drapery folds and the angles of the board point toward both the plate and cherries. Take care in drawing the cherries—not too large or too small.

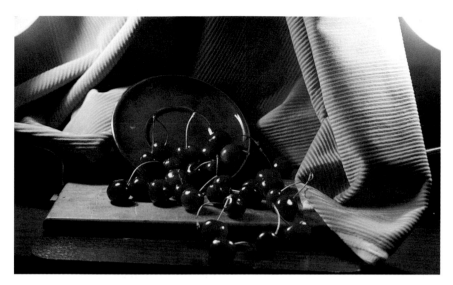

I propped up the plate after filling it with cherries, which fall naturally and spill onto the board and table.

In your rough sketch, a slight flattening of the top of the circle and inner circle will help to get the angle of the plate.

Lightly trace the completed sketch onto the ivorine using watercolor pencil—burnt umber for the table and board, red for the cherries, and pale gray for the folds.

STAGE 2

Underpainting With purple, blue-violet and retarder, use a #1 or #2 brush to paint in the background drapes thinly. Add more retarder, if necessary, to get a very pale color. Rub the color in with the paper towel. Repeat this, adding more color, and rub in again.

Remember always to touch your brush to the towel after you dip it in retarder, water, or color. *Twirl it to a point* when you pick up paint, and then touch it to the towel again. This should be done *automatically*.

Glaze the plate with diluted raw sienna, and the table with diluted burnt umber. Mix the two and, using less retarder, glaze the edge of the

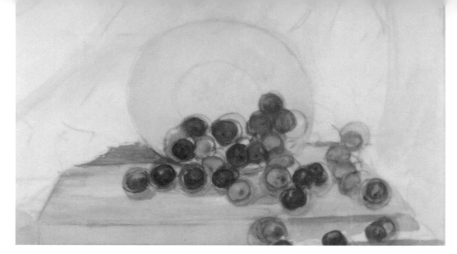

Add a second layer of color to the plate and the board. Mix burnt umber with Payne's gray, and go over the edge of the chopping board to darken it.

To glaze the plate, turn the picture around, keeping the paint on the line of the pencil and within it.

table. Use a smaller brush to glaze undiluted burnt umber for the edge of the cutting board. Then mix permanent green light with burnt umber, dilute with retarder, and glaze over the plate again.

Glaze the cherries with yellow-gold. Dilute the color with distilled water, so they will dry quickly. When the cherries are dry, glaze the cutting board with burnt sienna diluted with retarder. You can go right across the cherries.

Now, with a clean #000 brush, lift up color from the cherries—easier than painting the cutting board around them. Finally, with some red and yellow-gold, glaze over those cherries that will be a lighter red.

Sometimes you may find that retarder causes the lift-off of under-layers. If so, mix it with distilled water.

STAGE 3

For the background, mix blue-violet and black and apply with a small angle brush. Remember to flatten both sides of your angle brush in paint. A dip of retarder will allow you to work the paint better. Rub in gently with the towel, or tap down with a mop.

With less black and more blue-violet, pull the angle brush down the folds on the sides. When you are painting the draperies, each time you add some paint, come in immediately with the mop. Use it to create curves and blend the color, applying a little pressure, and twisting and twirling. If you get color into the plate while painting the drapery, immediately lift the paint off; do not let it dry.

Mix some blue-violet with white, and with the angle brush dipped first

in retarder, then in the color, pull gently down on the folds to the left of the plate and out to the edge of the picture. Allow the paint to dry and then glaze diluted ultramarine between these two left-hand folds and blend. Work similarly on the center-right fold, adding a touch of Payne's gray to the far right.

Permanent green light can now be mixed with blue-violet—do not use retarder—to produce an olive green. Paint in the deeper colors around the inside edge of the plate, over the bottom of the plate, and between the cherries.

Mix red with Bordeaux red and, with a 7000S or #000 brush, paint some dark edges to the darker red cherries. Darken some of the cherries piled in the shadow against the plate. Blend the darker edges into the red with the mop.

With yellow ochre, glaze another layer over the board and around the cherries. Burnt sienna can be glazed over the table. Then, dip a #000 brush into white and tip it with yellow-gold. Highlight the edge of the cutting board.

Bring the background color down to the back of the plate.

Painting around the cherries this time, glaze the chopping board with white. The color underneath will show through, and the white will add some opacity.

Stroke in some more white on the left end of the table, allowing the color underneath to show through.

Painting the drapes, remember to lend lightness to folds and edges that catch light, and to blend darks into lighter shades, to keep the folds looking curved and shadowed.

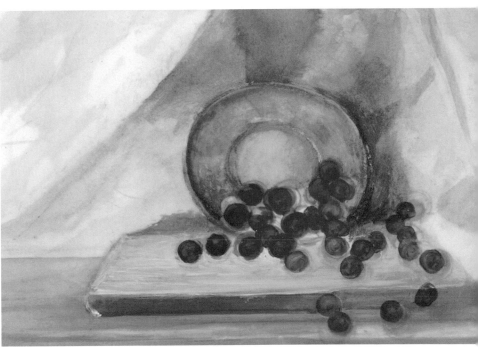

STAGE 4

Using Opaque White With the opaque white, paint over the cherries which have just the first glaze on them (*not* the darker cherries). You may have to do this twice and then sand down any roughness. As already suggested, the white, opaque base to these cherries will reflect back through the transparent glazes put over them later.

With white tinged with permanent green light, put in the cherry stalks with a very fine brush point. Put a little burnt sienna over the ends of some and add highlights on others with yellow-gold and white. A thin line of burnt umber should be drawn down the stalks opposite to the light source.

Drapery Background Now make a lilac color with blue-violet, purple, and white—not too pale—and work further on the drapery as follows:

The plate and drapery are given definition. Opaque white is applied to all but the darker red cherries.

1. Glaze color onto the right-hand drapes where color is needed close to the plate.

2. Add a little more blue-violet, and deepen the color on the far right. Before this dries completely, run some white down the edge of the right drape and the folds at the bottom. With a mop quickly pull the white into the color, then work it around to get a misty light on the edge of the drapes.

3. Use blue-violet and black to touch in any dark shadows on the far right, and pull that color back toward the damp, lighter areas.

4. Make the shadow under the plate quite dark. With the mop, let some of the shadow cover the cherries tucked in the deeply shadowed fold.

5. Put black and blue-violet also to the left of the plate, from the rim outward and down to the cutting board.

Defining the Plate Next, glaze over the entire plate with permanent green light, diluted with retarder. Mix blue-violet and permanent green light and, looking carefully at your reference picture, add in the curves in the plate where it is indented. The indentations go to the inner circle. A little lift-off down the sides of the indentations will emphasize them.

Mix some yellow-gold with white and carefully paint the edges of the plate and around the edge of the inner circle. Glaze over the upper edge of the plate with yellow ochre, and take it down to where the first cast shadow appears. Repeat the yellow ochre to the bottom right edge of the plate, and add a little to the left edge.

STAGE 5

Repainting the Cherries Now do all the cherries again with red undiluted with retarder (see opposite page).

Shadows Next, paint the shadows of the cherries on the cutting board. Mix burnt umber with a little blue-violet for the transparent shadow color. Start close to the cherries, and let the shadow fade as it moves away from the cherry. Pull some shadow over the cherries that overlap each other.

Next, add details to the plate, as shown in the close-up opposite.

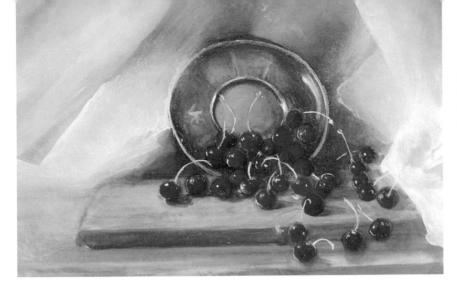

In repainting the cherries over the layer of opaque white, deepen the shadowed sides with undiluted Bordeaux red.

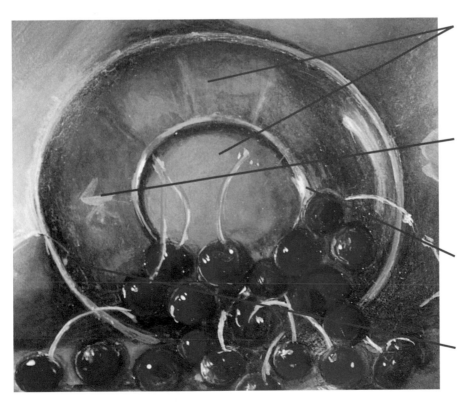

To add a glow to the plate, glaze a thin dilution of yellow-gold with a touch of red over the center. Extend the glow color in a small oval area in the upper rim.

Using your #000 brush, paint in lilac-colored highlights on the left side of the plate. If a highlight does not show up enough, repeat.

Add a highlight on the inner circle of the plate.

Mix permanent green light and blue-violet, and draw a thin line just inside the edge of the plate, using a #0 brush.

Stage 6

Continuing with the shadows, mix a shadow color from Bordeaux red, blue-violet, and black, and dilute it with a little retarder. Carefully paint deep shadows again at the left edge and the bottom of the plate. Add a glaze to the shadow over the top of the plate.

It is possible that when retarder is laid over retarder too many times the surface will thicken. As your completion of the painting nears, you need to be careful of this.

For the paler shadows on the left side of the drape, mix cobalt blue hue with blue-violet and a minute amount of black. Dilute with water. Paint in the shadow under the left-hand fold, and also beneath it near the table, blending this with the shadow already there.

Paint the soft, bluish shadow of the plate on the right drape with blue-violet, black, and a little cobalt blue.

Paint a burnt umber and Payne's gray shadow across the left corner of the cutting board and along the table to beneath the drape. Soften the edge gently with the mop.

The lighter color of the cutting board is reflected slightly in the table. Pull the yellow-gold and white horizontally, then with the mop blend it into the darker color of the table.

To bring up the table's wood grain, stroke a mixture of burnt sienna and burnt umber horizontally with the small angle brush.

Finishing Touches Twirl the brush to a point in white, tip it with lemon yellow, and point up the highlights on the plate. The original highlight may have sunk in a little, and this will bring it up.

With this same color, touch in highlights on the cherries. With a small mop, gently touch each highlight to spread it a little. After you have done this, return to the first cherry you highlighted and, if it is dry, highlight it again, but this time do not tap with the mop. Some of the stalks could receive a tiny catchlight, as well.

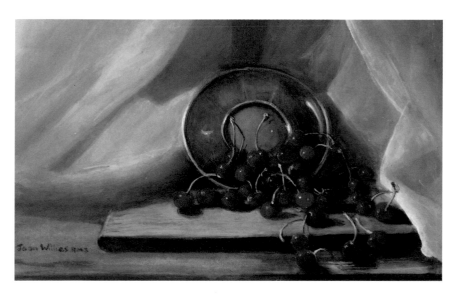

STILL LIFE
WITH CHERRIES

The completed painting, shown actual size. Transparent acrylics respond well to a varnish, but if the picture is framed and placed in a mat behind glass, it does not need to be varnished.

8 PAINTING IN TUBE ACRYLICS ON PLATE BRISTOL

Acrylic colors from the tube take well on most surfaces, though they may flake off ivorine. Because of the smooth surface of plate bristol, which we will use for this oval marine composition, tube acrylics are a good choice. Glazes of thin acrylic color one on top of the other will give your work a translucent appearance. Using many clear glazes I have painted pictures which reflect the morning, midday, and evening light. Working from the white base of the plate bristol, you can do this also.

Painting water with glazes, instead of thick paint, can be very satisfying. Pressing down on the brush, working with the point, laying the brush on its side and pulling it, and glazing—these techniques all come into play in creating beautiful water effects. Skillful brush work is the key to painting water, particularly when painting "in the little." This section will also focus on painting many details.

First of all, decide on the size of the oval and have a template cut. A framer will do this for you, probably quite inexpensively, from scrap mat board. You will find the template a useful prop for your studio.

MATERIALS

Your palette should consist of the acrylic tube colors in the box at left.

Select your brushes from the ones you have used for the previous paintings in water-soluble colors. Your sizes will range from #000 (or smaller) up to #1 or #2. An old, spiky nylon brush will come in handy, too. You'll also need distilled water and retarder.

The plate bristol board I have used for this demonstration is made by Strathmore.

STAGE 1

The oval template is placed over the reference photograph, taken in Nova Scotia, Canada, making the green boat the focal point.

I have drawn the basic outlines, including the buoys and engine mounting, and transferred this sketch to the plate bristol board with transfer paper and an HB pencil. Do not

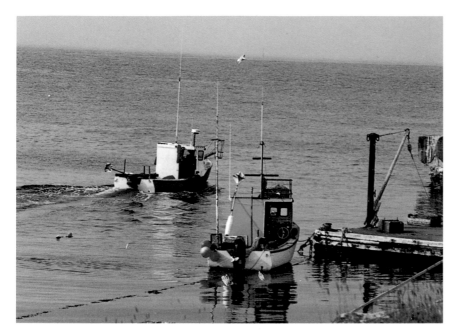

press down hard on your board; it will be indented if you do. Next, lightly draw over your lines with a gray watercolor pencil.

Place your oval template over the drawing and check the composition. Although you have drawn the masts they may not survive the glazes required for the sea. You could paint them in now with burnt umber.

Reference photograph for Cape Island Fishing Boats, Nova Scotia. *If you are not practiced in drawing boats, you can simply trace the photo. Or, rather than trace, place points for the shape of the boats; then the drawing can be completed freehand.*

Isolate the focal point with an oval mat.

STAGE 2

Blocking in the Water Start by laying in the sea with brilliant blue diluted in retarder. Use your angle brush and paint around the boats and the dock. Rub down with a towel, letting a little color go over the drawn lines, into the boats and the dock. Plate bristol has a hard surface; the paint will not sink in as it does on a hot-pressed board.

With retarder, dilute the brilliant blue, twirl the brush to a point, and tip it with Payne's gray. Work from the horizon toward the boats, and paint in tiny, slightly wavy horizontal lines for waves. Put them in haphaz-ardly and render them a little larger as you work toward the foreground.

Deepen the blue with a touch more of Payne's gray and add this to the front of the painting. Now take a dry, clean mop and stroke across the little waves. In the foreground, move the mop down and around, barely touching the surface of the waves. Rub the mop into the paper towel to clean off picked-up paint as you go.

Atlantic waters tend to be a blue-gray, and Nova Scotia's morning mists provide tints of pink, blue, and violet. You could mix a touch of cadmium red light hue into titanium white for a pink mist. With its fine point and wider reservoir, the Restauro brush would be good to use here. Drag the brush across the sky in one movement, then pull the paint down into the water. Follow through by sweeping the mop lightly across the sky.

With your #3 brush, use a creamy white diluted with retarder to paint foam here and there on some of the waves, starting at the horizon. Try wriggling the brush a little, and twist as you raise it.

Allow the painting to dry well. You will be adding more glazes, but the retarder prevents the acrylic paint from drying too fast.

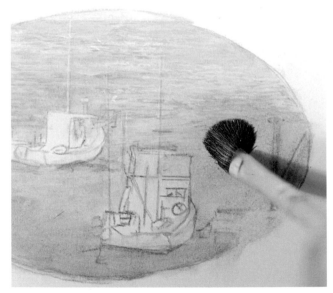

Adding and blending waves over the underpainted blue of the sea.

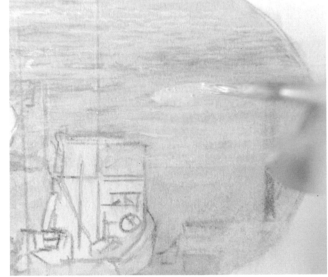

Introducing some whites.

STAGE 3

Waves and Foam With Payne's gray added to brilliant blue and retarder, put a wave in the wake of the moving boat.

Now we can add more glazes to the water. Dilute the blue-gray to a very transparent color and, with the angle brush, glaze across the whites you put in earlier. This will give subtle color changes to the water.

Mix a small amount of phthalo green with ultramarine and dilute with retarder to be a very transparent glaze. Using a #3 or #4 brush, glaze from the left across to the dock on the right. Just use the point to drag the color evenly across. Then stir your mop around on the glaze, giving it a misty look.

In adding more and deeper colored waves, make some of them longer, and start the longer ones farther back. This is done with the technique of mixing retarder and brilliant blue with Payne's gray, then coming back in with the brush laid on its side to add foam to the breaking waves.

For the water stirred up by the moving boat, make a transparent blue-gray. Lay the brush on its side along the top line of the wake, press down and drag it to the left. Twirl the brush to a point in the paint, and put a line in the wake, moving left.

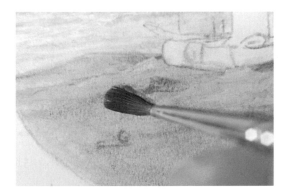

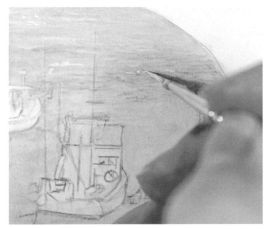

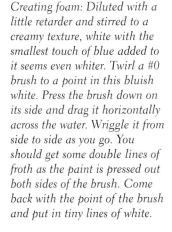

Each time you lay in a wave remember to use the mop and blend gently, barely touching the surface, to pull the different blues and grays together.

Creating foam: Diluted with a little retarder and stirred to a creamy texture, white with the smallest touch of blue added to it seems even whiter. Twirl a #0 brush to a point in this bluish white. Press the brush down on its side and drag it horizontally across the water. Wriggle it from side to side as you go. You should get some double lines of froth as the paint is pressed out both sides of the brush. Come back with the point of the brush and put in tiny lines of white.

Dip a #3 brush in retarder, then in ultramarine, and tip with Payne's gray to put in a deeper blue-gray alongside the moving boat. Pull the color away from the boat and, by pressing and then releasing the brush, create some troughs in the water. Note the trough at the prow.

STAGE 4

To begin working, first, on the moored boat, mix phthalo green with gray to deepen it. (In a miniature this green is too bright to be used on its own.) With the point of your #000 brush, glaze the green cabin of the moored boat. If the paint is too wet, blot with the paper towel; let it dry, then repeat.

Paint the cabin interior of the green boat with gray-white. When dry, go over it with a mixture of burnt sienna and Payne's gray to darken it somewhat more. Also dip the brush in retarder and then white and paint the side, prow, and back of the boat.

The details on the moored boat usually need only a touch with the point of your brush. Be sure you do not have thick paint on the point, and avoid putting pressure on the brush. Painting this detail requires patience, but is well worth doing. Take your time, and frequently rest your eyes.

On the back of the moored boat, you will need to underpaint some burnt umber in the area of the net. Make sure it is dry before you paint over this for the net itself.

Draw the mast in white with a fine-point brush that is springy, so that you can draw by just resting on the very tip. A Series 7 #00 is good for this.

The cross-pieces on the mast are painted with Payne's gray and phthalo green. These will need to be gone over a few times to strengthen them against the background.

Mix burnt sienna with burnt umber and a little retarder for the bilge hole. Add a touch of Payne's gray for the dark center of the hole. Drag a little of the color down to the bottom of the boat, making rusty marks.

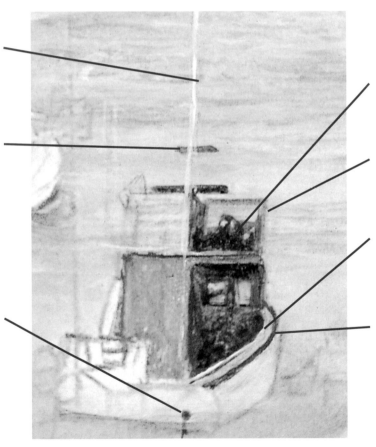

On the cabin roof is a box for ropes painted with cadmium red light hue and burnt umber.

For the framework holding the box, add black to burnt umber.

In tiny dots, take your brush around the point of the prow. Then paint down the side to the water line.

Once the white is dry, use burnt umber mixed with gray to paint the band around the boat.

Ropes and Nets Mix cadmium yellow with yellow ochre, burnt sienna, and a touch of white to paint the tiny ropes in the box on top of the cabin. Allow your first lines to dry, then put some more in, crossing some of the others for a coiled effect. One loop falls over the edge of the box.

On the boat's stern, paint in the net in cadmium yellow and a little white. Test your brush point on the palette; if it does not move in a smooth, thin line, add some retarder, and try again. When you are satisfied that you can draw a tiny, thin line, put in some tiny diagonal lines over the burnt umber. Refresh the brush and come back again in the opposite direction, making a tiny net of yellow. When this is dry, a few pinpoints of yellow mixed with white where the light falls will add sparkle.

The other ropes and lines are painted in with burnt umber, burnt sienna, and Payne's gray. Do the ropes tying the boat to the dock and the reflections from the dock. Put in some wriggly reflections beneath the ropes.

With burnt umber, go over the dock and the tall winch, and sharpen up the pulley if necessary with some Payne's gray.

Masts Both masts and the pole leaning against the green cabin can be drawn with a ruler and watercolor pencil in burnt sienna. Go over the lines with a #000 brush dipped in white. Some of the color will blend with the white. Repeat these steps with the paint and retarder mixed to a creamy consistency. With some burnt umber I've tapped in a few rusty marks on the masts. Do not paint blindly; you should see the mast as you stroke on the white paint. It gives you more control to draw down the mast, not up, so you may want to turn the picture upside down to do this.

The light is from the top left, so the right edge of the mast will need a shadow. Make sure that the white is dry before you attempt this. With the brush dipped in burnt umber and ultramarine and diluted with retarder, draw just the point of the brush down the right side of the

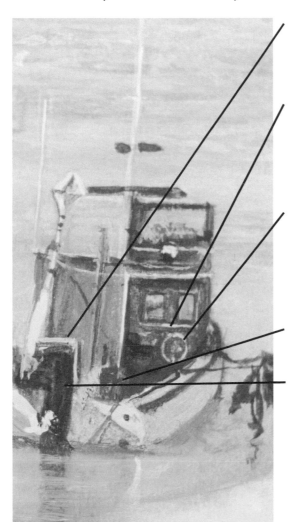

A hold for fish, the lid of which leans against the green back of the cabin, is painted in yellow ochre and white.

With a little burnt umber and white, lighten the area just below the window. There is also a window ledge which needs to be put in.

With your #000, put in some yellow ochre and white for the edge of the wheel. Later, come back and glaze shadows over part of it.

At the rear of the boat the lifebelt is painted with burnt sienna mixed with cadmium red light hue.

Paint the tarpaulin cover of the outboard motor using Payne's gray. Pull white through the gray for the folds of the tarpaulin.

mast, barely touching the surface. Try doing it in one movement. If you wobble, come down the side again with just retarder on the brush, and trim some of your wobbles.

Go over the pole leaning against the cabin with burnt umber and burnt sienna. It will become a warmer brown.

Putting in Reds Now dilute some cadmium red light hue with a brush dipped in retarder. Glaze the buoys again. Don't let them get too big—in miniature painting it is easy to enlarge things without realizing it.

Allow them to dry. Paint some of the red beneath the floats and with a clean, dry mop, gently pull the color downward to make a reflection.

Paint in the long marker with white, and do the red and white marker at the top.

Turn to the moving boat now, and paint in the reds. Put some burnt umber on the inside of the cabin and the left side of the boat, as you see in the illustration. With burnt umber, paint in the dock and make a start on the pole.

Shadows and Reflections

Reflections are always darker than the object casting the reflection and always go straight downwards. In moving water, they will have edges which curve in and out, but the image itself stays directly beneath the object. Shadows can lie across the reflections. The difference between reflections and cast shadows should be carefully observed.

Now wash in the reflection of the red boat. Put in white first, then glaze over it with a little Payne's gray and magenta, making a soft mauve. Pull this mauve color down into the water.

When the paint has dried, mix magenta, Payne's gray, and white, and paint in a mauve reflection of the bottom of the boat. Turn your painting upside down and work the mauve with a clean mop. You should get some realistic reflections in the water.

Paint the shadows on the moored boat with the mauve thinned with retarder. With white tinged with magenta, paint the end of the boat. This hint of pink will warm the light and make it look soft.

There is also a line of shadow cast by the tall marker. Use your mauve color and some retarder, and try to paint the shadow in one movement.

While you let the paint dry thoroughly, study the reference photograph for additional details.

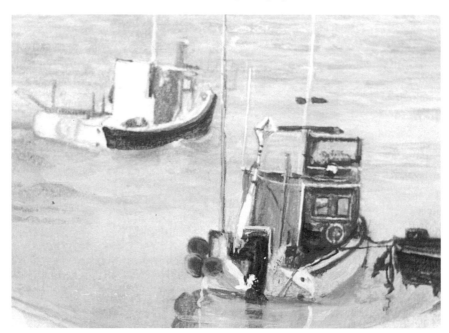

Painting in details and reflections, and the red of the moving boat.

With your #000 brush paint a tiny white line across the top and down the side of the cabin. If it is not opaque enough, let it dry and repeat. Trim back if your line gets too thick.

Glaze a little cadmium red light hue over the box on top of the cabin. The red is already muted, so the glaze will not make it too intense, but will give it a soft glow.

A rope falls down the stern into the water is painted with a mixture of yellow ochre, burnt sienna, and burnt umber.

The propeller which sticks out from under the cover can be put in with white and retarder.

Add some cadmium red light hue in the water under the buoys hanging on the boat. Stroke gently downward. The color will sink in and may need to be strengthened later.

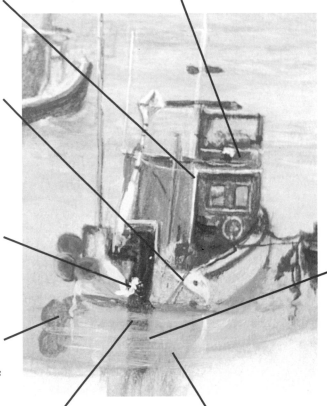

As usual, you should put an isolating layer on the painting. Dip a paper towel in retarder and gently rub it onto the dried painting. Only a little retarder should be on the towel.

Paint some diluted white lines across the reflections to create the appearance of rippling water. Just let this sink in without tapping it down.

With Payne's gray mixed with ultramarine, paint the reflection of the cover on the outboard motor.

Mix phthalo green with ultramarine and paint in the reflection of the cabin, taking it from the bottom of the boat down to the edge of the painting. Use a clean mop to whisk across the reflection.

STAGE 5

Red Boat Reflections and Wake As with the previous work on reflections, drag color straight down from the bottom of the boat, then with your #1 brush dipped in retarder, pull horizontally across the reflections, breaking them up and letting the water underneath show through.

Add just enough naphthol crimson to white to make it warm—not pink. Use the ¼" angle brush to put in a reflection from the back of the cabin.

Dip your #3 brush in retarder, then in ultramarine. Lay the full length of the hairs flat down along the line of wake at the rear of the boat. Press down and pull, angling the brush as shown in the illustration at top right. I have started from the left and moved toward the end of the boat. (You can go either way.) It will take probably three or four strokes like this. Each stroke should continue downward until the paint disappears.

Blend some of your ultramarine mixture with white. Use a smaller brush twirled to a point and dipped in retarder. Lightly paint in some pale blue waves.

To complete the wake, use the tip of the brush to paint in a line of froth where the waves splash against the red boat. Mix some Payne's gray with phthalo blue and deepen the blue on the right side of the boat.

Break up the waves using blue-gray diluted with retarder.

Continue the foam in the red boat's wake.

With diluted white, use your #3 brush to put some foam in the wake of the boat. Observe in the middle illustration on the facing page that the brush is pressed down the length of the hairs and is being stroked so that the paint separates into rivulets. Usually the first stroke gives you realistic water effects; you want to hold back and not touch it again. If the effects are not to your liking, lift off the white here and there.

To put in detailed, realistic foam flowing from the back of the boat, follow these steps:

1. Load the #3 brush with white as before.

2. Press the tip, then the side, of the brush where you want some foam. You should achieve an effect of foam rolling from each side of the brush.

3. Twirl the brush to a point on the palette without dipping into more paint or retarder.

4. With the point, break up the line of wash.

STAGE 6

Finishing the Water Go midway to the horizon and put in some blue-gray waves, capping some of them with white. Put some highlight over the sea on the horizon by glazing white with a touch of cadmium red light hue to

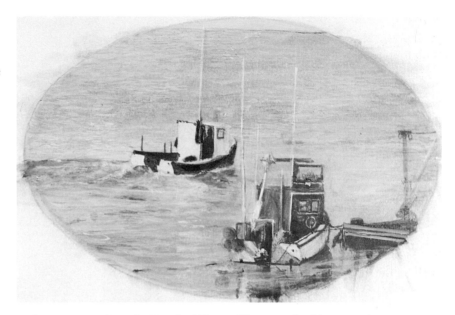

make it a very pale pink. Use the ¼" angle brush to do this, and swirl the mop around over the paint. Take it over the horizon line to get a misty effect between sky and sea, and tinge the water with a hint of pink.

Let the paint dry and put a last glaze of ultramarine with a touch of naphthol crimson and retarder over the sea from a point just below the horizon. The glaze should be very thin, just deepening the colors a little.

The red boat's pilot is silhouetted vaguely in the cabin. With Payne's gray and burnt umber, paint the shadowed cabin. Allow this to dry a few minutes. Then, with a fine brush twirled to a point, carefully paint in the pilot's head and shoulders.

The waves should get very tiny as you work toward the horizon and disappear altogether before you reach it.

Go over the side and prow of the boat with white. The plate bristol will absorb it, so let it dry, then go over it again with a diluted Payne's gray.

Paint the edge, roof, and back of the cabin white. Go over the edge of the window on the right of the boat with Payne's gray.

In repainting with another coat of white, just a little retarder will be necessary, but not too much. To get the bright white of the back of the cabin, you may need to paint a third layer. Keep each layer *very thin*. If you put too much paint on the brush, the paint will raise and look ugly. Of course, it can be sanded down if this occurs, but then the painting might have an overworked look.

With a #000 brush paint in the white masts. Draw the tall mast with the brush or a watercolor pencil in pale gray. The gray can be over-painted with white. The point of the brush can be guided along the edge of a ruler, but when removing the ruler, use firm pressure on one end to lift the other end up sufficiently for you to move it without smudging the paint.

Red Boat Details Now, with gray and burnt umber, paint in the details of the red boat: the outboard motor, the brown posts which hold the fish containers, the red buoy, and the red marker on the bottom left of the cabin. Turn your attention to the red boat's chimney-like equipment near the mast. The bottom of the tube is gray, the top white. Edge it with shadow using gray-brown. Paint a white flattened oval on top of it.

The cradle attached to the front of the cabin is for fishers to strap themselves into. Paint this in silhouette against the sea with a mixture of Payne's gray and a touch of black. The brush should be a #000 or finer. Use the magnifier, hold your breath, and take your time, to get it right the first time. The paint can be thinned to a slimmer line if you get it too thick.

With a yellow and naphthol crimson, paint over the back of the cabin and the end of the boat to brighten and give warmth to the white.

Paint a mix of cadmium red light hue with Payne's gray on the side of the boat from the prow as far as the cabin door. With a small clean brush, brush the color into the brighter red hue.

The red buoy is shadowed with cadmium red light and Payne's gray.

With Payne's gray and burnt umber, darken the small ropes.

STAGE 7

I put a touch of ultramarine mixed with yellow into the wake and also work this into the water on the right side of the boat—just a hint here and there. I touch up the reflections again in the front of the green boat, adding some extra green to the reflection of the cabin.

Now turn the picture on its side. Mix yellow ochre, burnt sienna, and white and paint three narrow lines along the side of the dock to represent the beams fastened there. With the point of the #0 brush paint thin lines, without pressing down, for the beams. Straighten the painting again, and with some tiny strokes of burnt umber deepen the edges of the beams here and there. Darken the top of the post to which the green boat is tied. Put in the post at the side of the dock and hang a rope from it, if you like.

Do not forget to reflect the post and rope in the water. Check on the reflections from the dock and pull a little white across them. With your old, spiky nylon brush, *very lightly* touch in white sparkles on the wake and *sparingly* elsewhere, such as amid the white caps around the red boat.

Paint in the seagulls, very tiny in the distance, larger as they near the boats. Use Payne's gray for the distant ones, and add a touch of white to the body and wings of nearer gulls. Watch the composition and do not add them haphazardly. I used my gulls to guide the viewer's eye out of the picture.

When the painting is thoroughly dry, feel it to see if there are any bits of paint or hairs on the surface. If there are, use your scrubber on the surface but apply no pressure. Brush it off and feel again. If the bumps are still there, sand again. You may have to touch up color if you sand the second time. (You do not have to sand the touch-up job.)

I suggest that even if you do not use a mat and glass, varnishing is a good idea, because it enriches the colors. Use a spray, going lightly across, then up and down. Allow to dry, then repeat twice more, until the varnish looks smooth. Alternatively, rub Schmincke wax varnish into the painting.

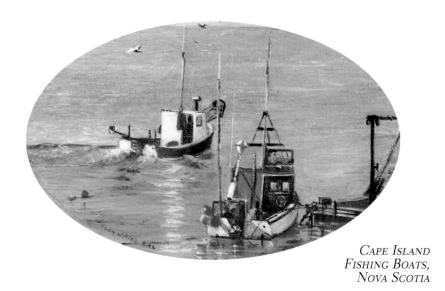

CAPE ISLAND FISHING BOATS, NOVA SCOTIA

When you sign the painting—shown here actual size— follow the line of the oval.

9 PAINTING MINIATURE PORTRAITS

A portrait in miniature is the most difficult of all the subjects you may choose. If you are a beginning miniaturist, unless you have painted and studied larger portraiture, this is not a subject you should start with. If you have painted portraits before, you still need practice "in the little." Likenesses are obtained by the minutest strokes, and a tiny mistake can lose you the likeness. For this reason, even with experience you should not work much smaller than an inch for the height of the head to start with. The two subjects that follow—a man's portrait, and then a woman's—will give you a lot of the practice required in drawing features and obtaining a good likeness.

Of course, you also want to practice by drawing someone who is very familiar to you. You should draw from life as often as you possibly can. Also, take many photographs of your subject. Make a grid, one on matte acetate and an identical one on paper. Lay the acetate grid on the photograph and, using this as reference, draw the same detail you see in each square into the square on your paper. (Draw only outlines, not shadows.)

Alternatively, mark the points of eyes, nose, mouth, ears, and outline of head on your paper by putting the photograph on a light box. This is not cheating, for however perfectly the head is drawn, you must acquire the skill to give it life and depth.

In photographing your subject, strive for soft shadows, which enhance personality. Flashbulbs often cause hard, dark shadows and bleach out colors and details. With a light-direction arrow at the edge of your picture, you are reminded how to modify these harsh effects. If you cannot set up side lighting, take your sitter outside for the photograph.

You should not find it difficult to add shadows missing from a flash photograph if you draw an arrow as a directional lighting note to yourself. Placing shadows from a new and imagined light source is not difficult, either, if you study the effects of light and shadow.

PROPORTIONS

There are some body proportions which are easy to remember. Most people think of hands as small, whereas they really are not. Place the bottom of your hand on your chin and spread your fingers. You will find that your fingers reach to your eyebrows or higher, and your thumb and little finger are about two inches from each ear. Remember this when painting hands, but do not draw them too large.

A hand-span plus the length of your middle finger gives you an average length of elbow to wrist. Arms hanging downwards reach approximately a hand-span from the knee—longer than you would think! Check your hand against various parts of the body and make notes. These will give you some basic guidelines for proportions; people do vary by several inches.

Children

If you sketch a child from life, draw an average child in the position you want the child to take, and draw in a large size. Do not attempt to make a sketch in a miniature size. While watching the child, note and draw his or her characteristics. A child's head is larger than an adult's in proportion to neck and shoulders. The eyes are farther apart than an

adult's eyes and they tend to be similar to an adult's in size, so in the small face they appear larger.

The lips are full and curved, and laughing or smiling. Soften the mouth, make it a little indistinct, and hint at the teeth with a touch of white. Lips should not be deep in color. Noses are usually short, and especially with babies and one- and two-year-olds the cheeks are very full. The upper lip of the mouth can hang over the lower lip a little. Ears appear to be large in proportion to the head, and the lobes of the ears are almost in line with the upper lip.

Take photographs of the child in the position you want for the portrait, but also take shots of him or her playing. Photographs taken with flash should be avoided. Give children something to hold in their hands. If you place them in a chair, unless it is a child's chair it will make the child look smaller. You may want to portray the child this way. A child in a doorway also looks very small. I often have my child sitters out of doors for a miniature.

Adults

Adults should be photographed and also called in to sit during the painting process. Sitting for the slow work of a miniature is exceedingly tedious, and a strained, bored look will result if you have somone sitting for days on end—miniature portraits just take longer than the larger portraits. Have your subject come back when you are nearing the end of the miniature to check on facial details and colors.

If you paint someone laughing, or smiling, soften the teeth. Do not paint spaces between the teeth, or pink gums. A half-smile is usually pleasant. The eyelids will elongate slightly in the corners, and the lower lid will raise. The nostrils will broaden. The shadows in the corner of the mouth will deepen a little, and the shadow under the lower lip will reduce.

Smiling will cause some shadowing from the nose along the indentation of the cheek to the corner of the mouth. Dimples will show more.

Lines and wrinkles should not be sketched into a drawing, but applied in moderation while painting. Neither should shadows be drawn. These are put in freehand when painting.

If you want to specialize in portrait miniatures and are not already practiced in drawing the head and human figure, it would be worthwhile to study drawing heads and the figure in depth; take a course, and simply keep on drawing and painting them.

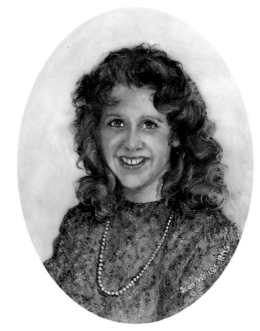

JAYNE

With a young subject, the mouth is almost always slightly open in a smile or laugh.

10 PAINTING A MAN'S PORTRAIT

PALETTE

Alkyds
Titanium white
Yellow ochre
Burnt sienna
Burnt umber
Van Dyke brown
Light red oxide
Rose madder
Cobalt blue
Ultramarine
Viridian
Payne's gray

Oils
Titanium white
Unbleached titanium
Burnt sienna
Van Dyke brown
Rose madder

When you paint a portrait, normally the area below the head should be at least the same size as the head, and slightly more—about one and a half times more than the head—is ideal. In an oval composition, such as this man's portrait, this is important. In this exercise, which adheres to this guideline, you will add many of the basics of portrait painting to the techniques you have already learned.

This man's portrait is done on ivorine. More practice follows with a woman's portrait on vegetal parchment. Though at this point it is not essential, in both exercises you should strive to achieve a likeness (the reference photos are provided).

When you do a portrait, have the person sit for you, if possible. With paint or watercolor pencils, paint some skin color on a piece of scrap and hold this to your sitter's face or hand. Add colors until you have a close match. Do the same with the hair. You can then get a good match for your painting when you do not have your subject in front of you.

MATERIALS

You will need your oils and alkyds (see Palette, left) and related materials:

"Recipe" medium (page 25)

Grumbacher Medium 1

Artist's mineral spirits

Set out your magnifying glass, scrubber and plenty of paper towels.

Note that the palette calls for an oil *unbleached* titanium. This is a transparent cream that will work very well for glazes over the flesh and highlights in the hair. There are two makers of this paint, Shiva and Grumbacher. The colors differ. In this painting I am using the unbleached titanium made by Shiva.

Brushes

Sables: #000, #0, #1, #2, #3, and #4

½" and ¼" nylon angle brushes

Silver angle 2020S

Mini-mop and detail mop

STAGE 1

Start with a drawing of our sitter, Paul. Work on layout paper or make a grid. If you are experienced in portraits you will be able to make the shape for his head, and place points for the eyes, nose, and mouth. If you are not experienced, trace the outside edges of this head onto layout paper using a light box or bright window. From this outline you can make measurements of the features, starting from the top of the head to the eye line. Draw a line which curves slightly upward across the head at the eye line. On the reference photograph, you will make many measurements— such as from the edge of the cheek to the edge of the outer corner of each eye. As you go, make the same measurements on your drawing and place dots to guide you in your drawing.

When you draw the eyes, the line you drew across the head should go through them, if you curved it slightly. Between the eyes, the space is wide enough for a third eye the size of the others. Measure the photograph for the width of the bridge of the nose. To get a good likeness this width, and the width and length of the eyes, must be exact.

If you draw a light line from the inner corner of each eye to the halfway point between the nostrils, you will have a long V. If you then draw a thin line from the outside corner of the eyes to the corners of

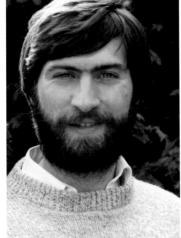

Reference photograph of Paul. Notice that the eye on the right is fractionally larger than the other. When you paint a portrait, little differences like this must be noted to achieve a good likeness.

Drawing the head is aided by measuring the facial features.

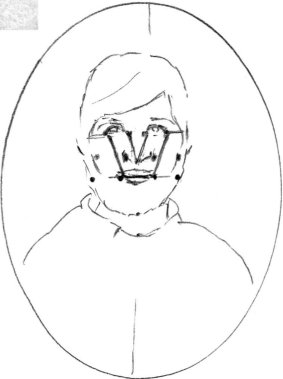

the mouth, you will have produced an outer V. The line taken from the line of the division of the lips marks the base of the V.

Make further measurements and points as you wish. In general, the bottoms of the lobes of the ears align with the base of the nose. Paul's ears are level with the top corner of his nostrils. Place a ruler across the top line of his nostrils and mark a point for the lobe of his ear on each side of the face.

Continue to draw, looking closely at the illustration and reference photo.

The completed sketch. Leave a half-inch of space, at least, between the top of the oval and the head.

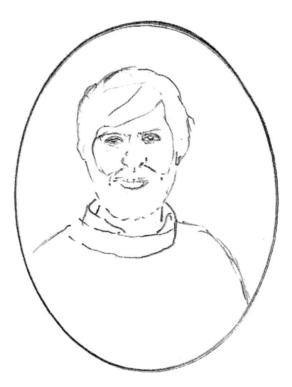

When you think you are finished turn the drawing to a mirror. If you have any wrong proportioning on the face, the mirror will show it immediately. Make any corrections necessary.

Measure the width of the shoulders, and outline the top of the sweater and the shirt.

You will need an oval template cut to size. Draw the oval on the ivorine, making sure you leave space around the edge for a mat to overlap slightly.

Next, erase the points, and the lines from eyes to nose, and transfer your drawing to the ivorine using watercolor pencils—gray for the sweater, burnt sienna for the face, and burnt umber for hair and beard. Note the light source by drawing a small arrow on the card behind the ivorine.

STAGE 2

Underpainting Start with alkyds diluted in Grumbacher Medium 1. Using your #2 brush twirled in diluted burnt sienna, paint very thinly all over the face and neck. With a clean brush, carefully lift off the lighter areas of the face and forehead, and also down the nose.

Make a thin glaze of cobalt blue, rose madder, and viridian. Using your small angle brush, paint in the background, and rub it down to a faint color with the paper towel.

Make a glaze of Van Dyke brown and medium and apply this to the sweater very thinly. Tap this with the mop instead of rubbing in with the towel to get a slightly woolly appearance. Paint over the neck of the sweater again, this time with less medium on the brush. This should give you a darker brown.

Underpaint the hair and beard with a diluted burnt umber, tapping with the mop to give a rough appearance.

Once the face is dry, lightly paint in the outline of the eyes with burnt sienna and burnt umber.

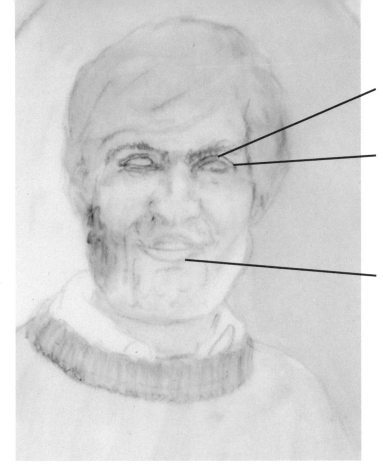

Mix burnt umber and burnt sienna with medium until it resembles a thin ink, and paint in feathered lines on the eyebrows.

Draw the fold line above the eyes, the edge of the eyes, and the line of the bulge under the eye in burnt umber and burnt sienna.

Outline the bottom lip with some light red oxide diluted to run like ink.

STAGE 3

Beard and Cheeks Twirl a #000 brush in medium and burnt umber. Testing on a spare piece of ivorine or on the palette, touch with the tip only and do not press as you pull some straight strokes downward. These should come out extremely thin. When you are satisfied, put in lots of tiny straight-down strokes on the beard, starting below the lip.

Work up the beard upward, letting the hairs go into the color of the flesh and letting the flesh show through in places. With a dry mini-mop, gently touch the beard without fuzzing the lines too much.

Dip the brush in "recipe" and then burnt sienna and light red oxide. Go over the cheeks with this; near the hairline, blend color with the mop back into the hair. Tap with the point of a #1 brush around the nose at the top and a little way down the sides of the nose. The paint should not be too wet.

With tiny taps, put in the color under the eyes, right up to the edge of the eye. Lift off a tiny line under the edge of both eyes. This will give you the highlight of the bulge of the skin in that area. Lift off again just below the lock of hair over the forehead.

Paint in a little burnt sienna below the chin. If your mop spreads the color into the nostrils, lift it off. The area on your left as Paul faces you is a little lighter on the nostril. Make a tiny lift-off there.

Also lift off some of the burnt sienna and burnt oxide across the top of the nose to create a little curve below it.

Starting the Hair Go over the hair with burnt umber and "recipe." Turn the painting around and paint from the part in Paul's hair toward the left.

Press and drag, then lift the brush to make a lock of hair with a highlight on the top and a point at the end.

Study the photograph to see the directions of the hairs, and paint them in one at a time. As you move to your left, touch gently with the mop to soften the hair ends. Longer and shorter strokes will result in a layer of hair.

Do *not* go over the hair a second time, for it needs to dry.

Eyes Move now to the eyes, and with your #000 brush dipped in "recipe,"

then in cobalt blue, paint in the iris of the eye. Make sure that the iris is not too large. Making eyes too large is a common flaw in portraiture. These eyes will need just a touch of color.

Notice that the lid of Paul's left eye goes up at an angle, almost to a point, and then comes down in a curve. The fold of the eye above the eyelid and the edge of the eyelid come close together. Draw in the two lines. If they are not quite close enough, bring them together with a tiny bit of burnt umber on the point of the brush.

The chin hairs should be pulled down in tiny strokes almost from the lip, leaving a small gap below it and to each side.

Painting the eyes. From time to time check to ensure that you are not making the facial details larger, which is easy to do.

STAGE 4

With rose madder, tint the lips lightly. Dip the #000 brush in Payne's gray, burnt umber, and "recipe."

Following the curve of the neck of the sweater, draw some fine lines with the brush. The lines should be close together. Keep cleaning and refreshing the brush, twirling it to a point and testing it on the palette before drawing these downward lines. When you have done this, go back with the same color and, barely touching the painting, put in horizontal strokes across each pair of lines, so that it looks like tiny knitted "ladders" of ribbing in the neckline. This will give a base of darker lines for the ribbing, which will be highlighted later.

The painting should now be allowed to dry.

When you start your next session, you may need to rub your scrubber lightly over the painting. Apply "recipe" all over the dry painting with a paper towel. Allow to dry again for about an hour.

STAGE 5

Sweater Detail Mix burnt umber, Payne's gray, and rose madder to make a soft brown-gray. Draw fine lines down the sweater. Follow the curve of lines at the shoulder, then straighten the lines a little as you work to the front of the sweater.

If you find this difficult, there is an alternative way. Paint over the sweater in the same brown-gray using Medium 1, not "recipe," to achieve a better lift-off. Lift off the lines of the knitting, instead of painting them in. If you want to suggest a heavier knit, make your lines a little farther apart.

Next, paint a series of diagonal strokes down one side of each line

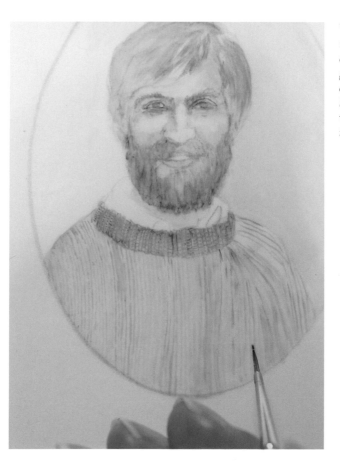

(the sweater is knitted in purl) to look like one side of a braid. Keep the lines light. When you have put in diagonals down each line, repeat the process, putting diagonals on the other side of each line, letting them cross the opposite one. Keep a space between your diagonal lines. You may want to practice on a spare piece of ivorine.

When the pattern is done, allow it to dry. Later you can glaze a thin warm color across it. The lines of knitting will settle softly into the glaze.

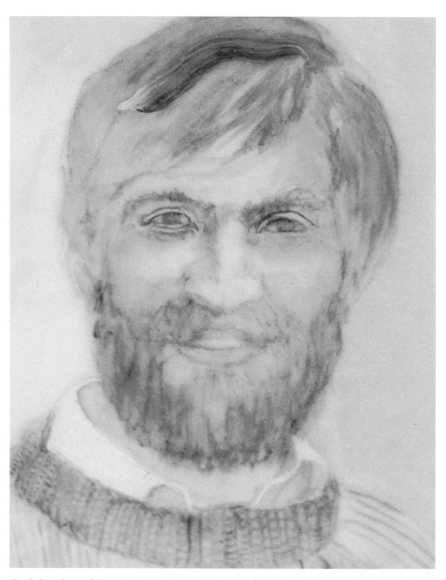

To define the eyelids, mix oil titanium white with alkyd burnt sienna and carefully dot the color in. Bring some of this color down the outside of the left cheek.

Collar Add "recipe" to alkyd titanium white and paint the white collar on the left. Mix rose madder, cobalt blue, and viridian—all alkyd transparent colors—with "recipe" and paint a soft shadow over the collar on the right. The shadow color should be painted under the left collar and inside the back of the left collar.

Mix some more of the rose madder, cobalt blue, and viridian with very little "recipe." Paint in a thin line of shadow just inside the knitted collar of the sweater on the left. Also deepen the shadow under the right collar. Leave the painting to dry overnight.

In the morning, polish the work with silk and rub an isolating layer of "recipe" over the painting. Leave it to dry for at least two hours.

Now dip your #2 brush in "recipe" and twirl it in burnt umber and cobalt blue, tip it with burnt sienna, and then take a tiny touch of the *unbleached* titanium. Put the brush point at the left of the hair, press it, then raise it slightly and pull into the curve of the hair toward the crown of the head. Take it into the parting on your right. As you drag it along you will see all kinds of colors coming out. The color at left will be lightest.

STAGE 6

Detailing the Hair With a clean, fine brush lift off a few lines of hair, as needed.

Use less cobalt blue and more burnt sienna and gently stroke the hair from the left of the picture up into a curve. Or use a different arrangement of color on the brush, if you like, but the last tip of color should be the unbleached titanium. Stroke as before, then feather and pull the lights into soft hairs on the left of the head. Work up the left side of the head and stroke lights into the darker area.

With a clean, soft mop barely touching the hair, brush upward from the left to just before the parting. Then blend from the parting down into the wave and across the hair on the forehead. You might lose some of the lines you have put there, but do not worry; it will pull the unbleached titanium up into the hair, giving more light to it on the left side. It will also give some movement to the wave.

Now allow the picture to dry. Twirl your #000 brush in alkyd burnt umber and burnt sienna and tip it with unbleached titanium to stroke in more of the hair as before, moving left to right. Use the tip of your #1 "Spin" brush to stroke from the parting in a curve toward the left. This should separate some of the

Blending the hair color.

colors, increasing the appearance of hair.

Try the "Spin" brush flattened into the same colors and lightly tipped with unbleached titanium. Take this again from the top of the parting and pull it downward a little, then flip to the left, making the wave which falls over the forehead. If a white line of highlight appears at the top of the curve, brush it into the curve with the mop.

If this works for you, stay with the "Spin" brush. If it does not, return to the #000, or use both brushes.

After a while you may notice that little raised bits of paint are showing up. Allow the painting to dry.

With yellow ochre and unbleached titanium, using a #000 brush highlight the hairs catching the light on the left. Highlight the edge of the beard also.

With alkyd yellow ochre and a point of unbleached titanium, paint a few lines down to the hair over the face to put a highlight on the wave.

Use oil burnt sienna and alkyd burnt sienna to glaze from the forehead into the hair on the forehead.

Add alkyd cobalt blue for shading alongside the face. Blend downward with the mop.

With alkyd burnt umber and burnt sienna, and a point of unbleached titanium, start at the parting and bring the brush down at the right.

With cobalt blue, burnt umber, and burnt sienna paint tiny loose hairs over the forehead.

With a clean, dry sable, brush the hair on the right to the edge of the face, softly blending the edges.

STAGE 7

Finishing the Eyes Paul's blue eyes have been touched in. Now mix cobalt blue with alkyd titanium white, making the very palest blue. With the #000 brush, *very carefully* light up the inside corner of the right eye. *Work in tiny dots.* Put a dot at the top, then another alongside it, and another beneath the iris.

Put a pale pink dot—from a touch of rose madder and titanium white—in the corner of the eye.

There is hardly any white on the outside edge of this eye. You could put just a pinpoint of white there, but it must be no larger than a pinpoint.

At the bottom of the eye you could touch in a couple of white pinpoints for the wetness in the eye. Do this for the other eye, too. This eye has more white showing on the outside edge. A minute touch of pink can be added to the inside corner of the eye. *Do not touch with the mop;* let the eyes dry.

Placing the pupils of the eyes is the most difficult thing in a miniature portrait. They must be neither too small, nor so large that they obscure the iris. For the pupils of the eyes, never use black on its own. Black can give a look of meanness to the eyes. Instead, use burnt umber mixed with Payne's gray. Dip your brush in "recipe," hold your breath, and place the pupil at the upper center of the iris in one stroke. If the pupil is too small, re-point the brush and touch it a second time.

You can make the face come alive with a tiny spot of reflected light in the eyes. To do this, twirl your brush in oil titanium white mixed with alkyd titanium white. This will give you the flexibility of the oil with the opaqueness of the alkyd. Place the tiny pinpoint of white in each eye at about the 11 o'clock position; on the right it just overlaps the pupil.

Finishing Touches The face must now be dry enough to glaze. Mix the color of this final glaze observing the sitter's type of skin. Usually, for a man, you would paint the final glaze in a well-diluted oil burnt sienna. Paint thinly all over the face, and it will give you a glow. (When glazing the flesh, make sure that the brush cleaner you are using is clean.)

Return to the beard. With the #000 brush, go over the dark areas with tiny lines of burnt umber mixed with cobalt blue and oil Van Dyke brown. Put in wriggly hairs coming from the edge of the beard. Go around the entire beard. You may find that the long point of the Restauro #1 brush will do this well.

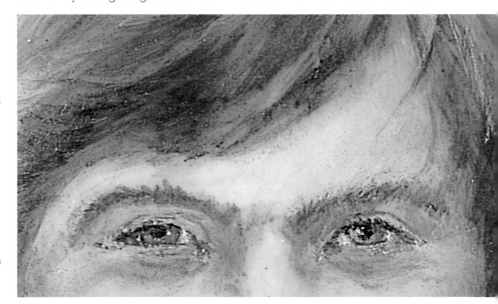

You have to use artistic license when you paint eyes that were photographed in a bright light, for the pupils shrink, making the person look angry. Paint them slightly larger.

Paint straggly hairs going up slightly from the beard to the cheeks; make them appear to grow from the skin there.

On the mustache, bring down long and short wriggly hairs.

Just below the chin are some grayer hairs; add a little white to your mixture. Always let the dark underneath show through.

Add a few blue-gray highlights here and there in the beard. Touch lightly with the mop.

STAGE 8

Following the steps below, put the following finishing touches on the nose and mouth. After each step, soften the effect with a touch of your small mop—an essential refinement in miniature portraiture.

1. With oil titanium white and a tiny touch of rose madder, paint down the left side of the nose.

2. Put a highlight on the right nostril using the unbleached titanium and titanium white.

3. Mix some burnt sienna with the unbleached titanium oil and put a little of that color on the right of the nose by the eye.

4. Paint the edges of the teeth very lightly with a dilution of burnt umber and ultramarine. The color should dry, then a glaze of oil titanium white should be painted across the teeth. The lines will show through the paint.

5. With tiny lines of oil rose madder mixed with a little yellow ochre, give a glow to the lips, starting with the upper lip. Then lift off highlights. Repeat this on the lower lip.

6. The upper lip will need to be slightly shaded. Put in the tiniest of dots in burnt sienna just in the bottom center of the upper lip. In

the corners under the mustache touch a little burnt sienna on both sides of the mouth.

7. With burnt sienna and cobalt blue, shadow the mouth at the top of the bottom lip.

8. Put in alkyd and oil titanium white highlights in tiny lines on lips and add two of the tiniest dots possible to the two left-of-center teeth. Use the mop gently, just to spread them a little.

9. Use burnt sienna to paint in the neck. The hairs already painted there can be glazed over. Put in a stroke of unbleached titanium at the edge of the neck.

The background should now be deepened. Using alkyds, mix cobalt blue, Payne's gray, rose madder, and veridian. If you want just a glaze, wash the color in with a #4 brush. If you like more texture, flatten an angle brush in the paint and tap in color, moving up only as far as the area around the head. Do the same on both sides. On the left the sweater, being light-colored, will show up better if the color there is darker. Whether you stipple or lay the color in, the soft mop should be used to blend the darks and lights together and to soften stippling.

Mix burnt sienna and titanium white plus a little unbleached titanium and add final highlights to the hair, which now should be dry. Use tiny, thin strokes just a few at a time and highlight the hair on the left. Do not add too many strokes, or you will lose too much of the dark.

With a little burnt umber mixed with unbleached titanium, paint in the ears, which are just visible on both sides.

Work on the sweater's finishing touches. Go over the ribbed neck with Payne's gray and burnt umber and darken the ribbing on the right. With some unbleached titanium, pull down some tiny lines of ribbing on the left shoulder and on the left side of the neck. With some rose madder, viridian, and burnt sienna

variations on this color, go over the V shapes you put in earlier. Add V shapes of unbleached titanium mixed with alkyd titanium white on the shoulder lines of the sweater.

Finally, take your mini-mop and holding it straight downward, go over all the wet areas on the sweater, tapping down gently. This will give the sweater the soft fluffy look of wool.

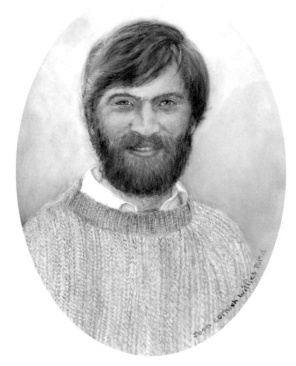

PAUL

The completed picture, shown here actual size, should be protected by either a matte varnish spray or Schmincke wax varnish and put in a frame. The colors can be enhanced by placing acid-free foil paper behind the ivorine. (Do not glue the foil or paint colors on the back; you will stain the ivorine permanently.)

11 PAINTING A WOMAN'S PORTRAIT

PALETTE

Liquid Transparent Acrylics
Burnt ochre
Burnt umber
Red
Ultramarine

Liquid Opaque Acrylics
Titanium white

Oils
Titanium white
Unbleached titanium
Cadmium yellow
Indian yellow
Gold ochre
Burnt umber
Van Dyke brown
Light red oxide
Cadmium red medium
Rose madder
Light blue-violet
Cobalt blue
Ultramarine
Olive green
Payne's gray

Interference Colors
Pearlescent shimmer (white)
Interference lilac
Interference blue

The support for this portrait, *Beryl*, is different—vegetal parchment—and a little gold is introduced. I also introduce the use of *interference colors* developed by the Daniel Smith Company. These are optional.

MATERIALS
We will mainly do the underpainting with the more liquid transparent, bottled acrylics. These will glow through the subsequent oil layers. Basically, one *very* thin glaze of the acrylics—the underpainting—should be used.

Krylon spray (#1303) or Rabbit Skin glue

Matte acetate

Acrylic retarder medium

Grumbacher Medium 1

"Recipe" (see page 25)

Shell gold

Brushes
Use separate brushes for oils/alkyds and acrylics, if you can. If not, wash the brushes when you switch mediums.

Sables: #000, #00, #0, #1, and #2

Silver 7000S brush

Mini-mops and detail mops (as many as you have)

You will need your watercolor pencils and the other materials you customarily have by your easel.

The surface of your support should be sprayed with acrylic resin, which is resistant to both mineral spirits and water when it dries. (You could also use the traditional Rabbit Skin glue sizing.) Allow it to dry thoroughly. The resin is used to protect the fibers of the parchment from the color in acrylics, and from the oils in oil colors.

Using the parchment, your colors will sink in a little, and will need going over several times. As the colors sink in, they help the oil to dry, so you can paint in longer sessions.

STAGE 1
To pick out an attractive subject from a photograph without using everything in the photograph, you can make a paper frame, and move it across the photograph until you find a portion which composes well. Beryl's picture was taken by flash, so the

composition, shadows, and lighting need to be changed.

The size of the oval is 3⅞" x 2¼". Dilute opaque white with a little retarder and *thinly* paint your sealed parchment cut to a 4" square. This provides plenty of room for drawing. Allow to dry, and prepare your drawing.

Make a grid of half-inch squares in your sketchbook and trace this onto a sheet of matte acetate. There should be sufficient squares to be able to lay over the picture at right.

Trace the oval shape of the painting onto the acetate. Measure and draw a center line across it. Check this over your grid in the sketchbook, making sure the center line you have drawn in the oval is lined up with the center line of your grid.

Clip the sheet of acetate on which you have drawn the grid over Beryl's photo on this page. Trace the outline of the facial features, hat, shoulders, and neckline, square by square, within the grid you have drawn in the sketchbook. Use a very sharp-pointed pencil. Make the height of the forehead, the crown and brim of the hat, the eyebrows, and other features as accurate as you can. Indicate details with dots—for example, two dots for the top and bottom of the curve of the cheek, from the corner of the nose to the corner of the mouth.

Transfer the sketch to the parchment with a sharp-pointed watercolor pencil; do not draw too heavily.

Reference photo of Beryl. Normally a painter avoids a laughing portrait; half-smiles look better. There are exceptions like this one, however.

In the sketch, focus on the lines and points you need to ensure a likeness. You do not need to draw the flowers or jewelry.

STAGE 2

Underpainting Start with *acrylics*. Use your #2 brush to paint over the face and arms with opaque white acrylic mixed with burnt ochre and well diluted with retarder. The arms will be painted over later with the sleeve of the dress. Since the dress is silk, the color of the arms will show through the folds of the sleeves.

With a piece of paper towel placed carefully over your painting, press down gently to make sure the paint is dry. This will prevent the parchment from buckling.

Turn now to the *oil* colors. Mix titanium white, Payne's gray, and light blue-violet. With your #2 brush, paint this into the background. Swirl the mini-mop around; use it more firmly on the left, so as to keep that side light.

Here are some steps to follow with the oils:

1. With light red oxide diluted with Medium 1, glaze over the face and arms. The color should just be a delicate tint.

2. Paint in a mixture of titanium white over the undergarments.

3. Add pinks to the hat by mixing a touch of cadmium red with titanium white.

4. Now put some interference lilac on the palette well away from the other colors. With a #2 brush dipped in "recipe," paint a tiny amount of the lilac over the brim of the hat and on the crown. This will hardly show, but there is a glow there. This is how you will use interference colors on clothes or brocades—sparingly. You have to be careful when using interference colors in a fine-art miniature. The effect must be very subtle—now you see it, now you don't.

Paint the pale pink hat brim and crown with white and a very little touch of red.

Paint the flowers in titanium white mixed with red and also in diluted red.

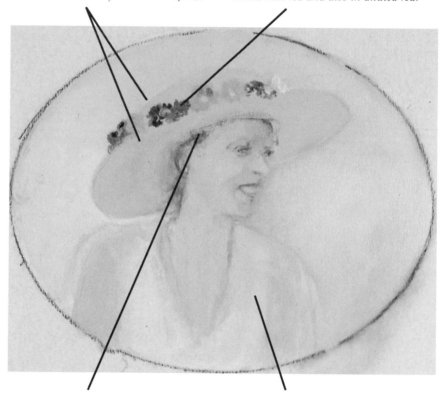

Paint the hair in pale burnt umber diluted with retarder. Only a hint of color should be seen.

With white diluted a little, block in the undergarments.

STAGE 3

Beginning the Facial Features

Allow the flesh colors to dry, then start working with the details of the face. Use burnt umber and Payne's gray and a #1 brush (Restauro is a good choice here) to paint the eyelashes of the left eye, then just one or two on the right eye.

If you get this too thick, don't lose patience—it can be lifted off. But it does not lift off as well as if the ground were ivorine. Rather than struggle with the small brush, lift it out with a larger brush dipped in "recipe" and dry with the towel. If the lift-off is not successful, mix some titanium white, with light red oxide, and paint out your first attempt.

Mix light red oxide with cadmium red and some titanium white and, with your brush dipped in "recipe," tap the color to the curve of the cheek. Follow the line of the cheek where she is smiling. Use a small clean sable to pull the color back up the cheek toward the hairline. Tint the other cheek similarly.

When you paint women, even if they are wearing lipstick, subdue the lips in a miniature. Light red oxide gives a pleasant pinkish brown to the lips that is very natural. Add a touch of this to the point of a #000 brush and put in a little bowing line just below the nose. Tap in the line along the top lip to the corner of the mouth.

Mix burnt umber with Payne's gray, and paint a little shadow under the chin and down the neck. Put this in with the tip of a #0 or #1 brush. Use the detail mop to blend the color to the left.

Mix some light red oxide with some titanium white. This is needed to give a highlight to the fold on the side of the chin. Using the #000 brush, lightly draw in the two lines there. Features such as these two lines will increase the likeness you want in your portraits.

With the light red oxide and Payne's gray, outline the chin to sharpen it up a little.

Flowers For the anemones on the hat, first mix a touch of the interference lilac with rose madder and some titanium white. This will give you a base for putting in the pink flowers. Then add more rose madder and go over the pink flowers again, deepening the colors almost to red, leaving a little circle of the pale pink in the center. Mix blue-violet with the interference lilac, a touch of rose madder, and titanium white for the violet flowers.

Now leave the painting untouched for at least a couple of days. This will allow the oil to settle in and dry.

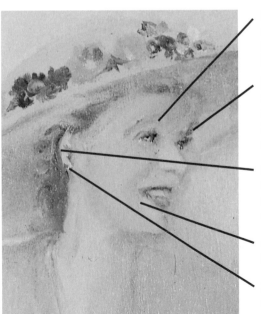

Mix some Payne's gray and light red oxide and carefully paint the eyebrows in a series of tiny feathered strokes.

Paint a soft shadow alongside the right eye, going up the forehead and under the brim of the hat. Let some of the shadow color spread over the forehead.

Use Payne's gray and light red oxide to render the edges of the ear. Let this dry before bringing any hair down over the ear.

Also paint the little "laugh line" going down to the chin.

Paint the lobe of the ear with titanium white, mixed with a little light red oxide.

STAGE 4

Polish the surface and rub in an isolating layer with "recipe," but only when you are sure the surface is thoroughly dry.

Mix olive green with ultramarine for the blue-green leaves on the hat. Use the 7000S to go over them several times as the color sinks in. Then go over the pale violet anemones with Payne's gray mixed with light blue-violet, or (if you want a stronger mauve) ultramarine.

Paint in the tiny, deeper violet petals of the anemones, and then put in some tiny white highlights with titanium white, to which you have added some pearlescent shimmer, a white color similar to mother-of-pearl.

The Eyes With titanium white, put a minute point of white in the corner of the left eye and a pinpoint of light in the right eye.

Mix Payne's gray with ultramarine, and put in a tiny line of blue-gray alongside the tiny white point you have put in. If the white is still wet, try not to get it mixed. When the eye is completely dry, you can put in a tiny straight line of Payne's gray mixed with Van Dyke brown for the pupil of the eye. If you do smudge the white, wait until the eye has dried and then go over it again.

The Dress and Hat To paint the dress, mix Payne's gray with light blue-violet. Place the point of your #2 brush on the right shoulder and stroke straight down, pressing as you go, curving the fold in the fabric. This action will push deeper color right and left of the brush. Refresh the brush and place the point at the top of the shoulder for the next fold, press and pull. If you want a narrow fold, just press down on the tip. If you want a wider fold, press the brush almost down to the ferrule. You may want a couple of wider folds at the neckline and the edge of the sleeves. This is fun to do. You should get some darks in some of the folds. Lift off where you want lighter colors, but do not try to highlight with paint just yet.

Mix some titanium white with rose madder and make a pale pink. Dip the 7000S brush in "recipe," then with the picture on its side, draw the hat's pink brim in one long line, if you can. The upper corner of the hat is shadowed, so you should start your line just on the curve.

If your line will not make it all the way in one movement, start another line halfway. Then clean the brush, dip it in "recipe", and run this down the edge of the hat. This may pull the broken lines together.

Mix blue-violet with some ultramarine and Payne's gray. Using the #000 brush, start to detail the flowers. Deepen some of the blues and violet-blues. Add some rose madder to the deep pink anenomes.

Return to the dress. Mix blue-violet with Payne's gray, making a darker blue. With a #000 brush put some shadowed lines between the folds of the dress, and sharpen the edge of the neckline. Use the mini-mop to soften the folds.

Now use interference blue to paint between the folds where they are the darkest. Finally, do the underpainting for the necklace in white.

Background Mix Payne's gray and light blue-violet and go over the background again with a #2 brush. Load it with paint and use long strokes. With a mop, tap down on the right side to give some texture. Blend the color between the flowers and the background just above the brim of the hat. Blend the background color into the sleeves as well.

Add a darker area of soft background shadow to the right of the hat and down the edge of the face.

Mix gold ochre, Van Dyke brown, and titanium white, and paint the hair. Blot with a paper towel for a pleasing effect.

Mix gold ochre with titanium white and run the very tip of a #000 brush over the curls at the back of the hair where the light catches.

Paint some of the wisps of hair over the forehead and ear.

With light red oxide and white, mixed to a creamy color, paint the little puff under the eye.

On the upper part of the cheek, use light red oxide with a touch of rose madder. Paint in to the nose and the side of the mouth.

Touch in the teeth with titanium white, but do not separate the teeth with lines.

Touch up the mouth with light red oxide. Place the mop on it once, then take it away in one movement.

Paint the strand of ribbon just below the hair on the shoulder with a dark violet of rose madder and Payne's gray.

Stroke a light line for the tendon from her ear to her neck. Tap this gently with the mop.

Mix Payne's gray with light red oxide, dilute with "recipe," and add to the shadow down the neck.

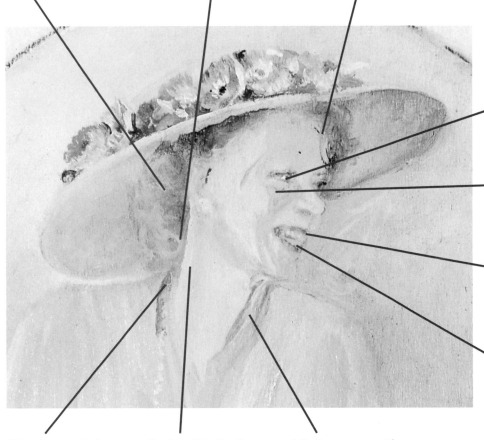

STAGE 5

Facial Coloring The face should now be tacky dry. Mix unbleached titanium and light red oxide. With a few dots of the paint, bring up the highlights on the upper cheek and the area between the curve of the cheek and the upper lip. Place a tiny touch on the brow below the eyebrow and down the side of the neck, next to the hair.

Now it is for you to decide whether areas of the face need more color and how much. Consider the cheeks and the neck, and the flesh tones under the eye, lower lip, and chin. The color you have put on the painting has most likely sunk in a bit. If you think these areas can receive more color, dilute burnt sienna, which is a transparent oil, with a little "recipe." Add the color where you think it is needed with a small sable brush, and allow to dry.

Return to the face with the mixture of unbleached titanium and light red oxide and now highlight the cheeks, the back of the neck, the tendon. Don't forget to use your mop for blending.

At this point, also put in the white underpainting for the earring.

Hair Mix cobalt blue with yellow ochre. Put in this gray shadow color on the hair. Mix yellow ochre, cadmium yellow, and titanium white to go over the highlights of the hair again, letting the ends of your fine lines go into and mingle with the shadow color. When this is dry, mix Indian yellow with titanium white, and add to the highlights.

Mix a little cobalt blue and burnt sienna and put in a tiny shadow from the loose hairs on the forehead, just behind them. Do not try to repeat the stroke. If it does not satisfy you, do not use "recipe" but wash the brush in mineral spirits and gently lift off the error. Then repeat.

To test your skill further, add some feathery shadows to the hairs over the ears.

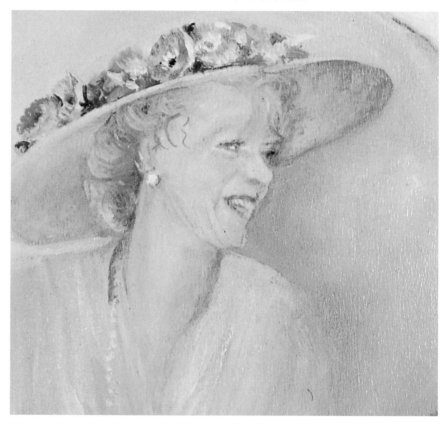

Because of the flash photography, the skin in the reference photo is too white. Your painting should give some color to the face, with the highlights just showing.

STAGE 6

Dress Details The dress is ruched on the shoulder line. Mix Payne's gray, violet blue, and a touch of rose madder and stroke some darker color on the top of the right shoulder. Put in tiny lines of color across the shoulder, bringing them down a little into the folds of the material. Use the detail mop to pull down and stretch the lower lines you pull down from the ruching.

Go to the left-hand, lightest shoulder and repeat the process, and then pull lines down in a curve toward the neckline.

Also paint down the sleeve in the direction of the arms. Pull down with the mop and curve the bosom lines toward the neckline. Mix some white with your color to add some highlights on the folds and the left sleeve.

Jewelry The final steps using interference colors are really optional: adding the long pearl necklace and the smaller gold necklace with the pendant. Using pearlescent shimmer mixed with some Payne's gray, tip your 7000S or #000 brush and paint the shadow of the long necklace in shadow, one minuscule link in the chain after the other. If this defeats you, just paint a thin line all the way down both sides. Allow the paint to dry *thoroughly*.

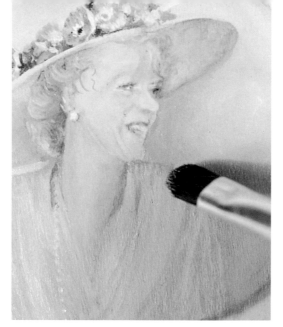

Left: Starting the ruching on the dress.

Below: Finish the dress and paint the bow on the ribbon with rose madder and Payne's gray. Add white for highlights.

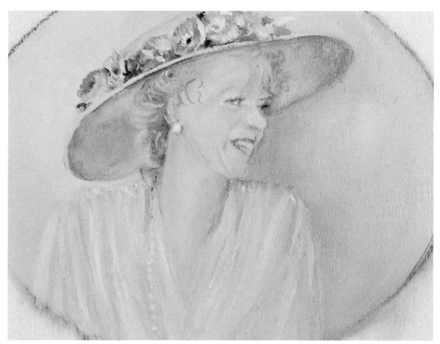

The shell gold, in tablet form, is diluted with distilled water, forming a creamy solution. In painting, try not to rinse the brush; just add a touch more water to the tablet, for each time you rinse the brush you lose gold.

The pearls can be put in with titanium white only, or titanium white and pearlescent shimmer. Use the #000 or 7000S twirled into the finest point you can in the paint. Each pearl is a minute dot on the chain. You can only put in one or two at a time, then you have to refresh the brush and its point. Slowly and carefully go all the way down the chain. If you are right-handed paint the chain on your left first, then turn the picture around, and go down the other side without changing your brush angle.

Add an earring of pearlescent shimmer to the ear, or any gemstone which will match the pendant.

For the gold necklace, you will need a capsule of 24-karat shell gold (see suppliers list). The name "shell gold" was given to it by the early illuminators, who would mix finely powdered gold with glycerin or gum arabic and let it dry into a tablet, which they set in a mussel shell.

Twirl the brush in the gold and carefully paint tiny sloping lines side by side down the two sides of the necklace. You may need to turn the picture to do the sides. Make a mix of burnt sienna and Van Dyke brown and use a different brush. Put tiny lines over the gold to indicate the twist of the necklace. You do not have to paint them all in, just a few.

Go back to the brush you have used for gold to paint a tiny circle of gold for the pendant. Then a minuscule touch of shadow is needed

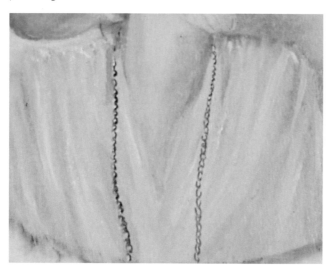

Painting the long necklace, shadow first.

Adding the pearls to the necklace and painting with shell gold.

to the right of the necklace and pendant. Use Payne's gray mixed with burnt umber.

In this painting the pendant is a ¼-point diamond firmly glued into a pinhole in the parchment. Setting gems into miniatures has been done for centuries since medieval times. Painters of miniatures in Italy have specialized in this right to the present day.

Some Alternatives Oil gold ochre with metallic gold paint can be used for the gold necklace, if you prefer; you can also paint it without the metallic. Highlight it with Indian yellow mixed with a touch of titanium white.

To make this necklace with gold leaf, you will need 22- or 23-karat gold leaf that is lightly adhered to transfer tissue (obtainable from The Calligraphy Shoppe or Daniel Smith).

First, dust the painting with talcum powder, and then shake it off. The powder will prevent the gold from adhering where you do not want it. Next, the necklace will need to be painted in with gold adhesive, available from Miniature Painting, Etc. (see suppliers list). Apply the adhesive, taking it through the residue of powder in the tiniest of dots; then let it dry for an hour. When the adhesive looks clear, cut a piece of the transfer tissue with a fine

blade dusted in talcum powder. Rub a clean sable brush in your hair, to capture the static electricity, and hold this to the tissue. The tissue will cling to the brush. Now *breathe heavily on the adhesive* to moisten it sufficiently to receive the gold. Lay the tissue gold-side-down over the necklace. With your hand dusted in talc, press down gently with your finger along the line of the necklace. Leave it for

at least half an hour. Have ready a small baby-food jar with a lid, filled with water. Hold the painting over the open jar and brush the gold gently with a mop. Surplus gold bits will fall into the jar, leaving you a thin gold necklace and pendant. Let the gold dry overnight. The next day, remove all the talcum powder, and burnish the gold a little by rubbing it with a piece of silk.

BERYL

The completed painting, shown actual size, in its gold frame.

PAINTING WITH DECORATIVE EFFECTS

PALETTE

Alkyds
Titanium white
Burnt sienna
Burnt umber
Van Dyke brown
Light red oxide
Dioxazine violet
Phthalocyanine blue
Ultramarine
Payne's gray

Oils
Unbleached titanium
Titanium white
Burnt sienna
Raw sienna
Translucent brown oxide
Brown madder
Van Dyke brown
Vermilion
Cobalt violet
Cobalt blue
Phthalocyanine blue
Phthalocyanine green

Oil Interference Colors
Pearlescent shimmer (white)
Interference lilac
Interference blue

This final exercise is an excellent way to combine the kind of exotic effects of the Indian miniatures you saw in section 1 with both old and modern materials. The subject is Alexandra, a dancer portrayed in silken and jewelled clothing; the ground is a 5 x 7" piece of ivorine.

In earlier centuries when gold was in more regular use, brocades were painted as shown here. Yet it is not necessary to underlay the skirt with gold leaf as is done in this lesson. Moreover, you can use gold ochre and white or interference gold for the details.

We will focus on techniques, not the likeness of the woman in the picture. In many ways this is the most challenging picture to copy, and the most challenging part is the face. But aim for the *basic* facial details and study the turn of the head carefully.

MATERIALS
You will need your full collection of brushes and the materials you customarily use. Additionally, be sure you have the following:

Matte acetate

Layout paper

Glassine paper

22- or 23-karat gold leaf on transfer tissue

24-karat shell gold

Gold size or gold adhesive

Grumbacher Oil Painting Medium 1

"Recipe" (see page 25)

Mineral spirits

Talcum powder

Small container of water

With the exception of brown madder, unbleached titanium, and phthalocyanine green, the oils I have used are Schmincke Mussini resin oil colors. These paints are very finely ground, and all are transparent.

For your initial drawing you will need your watercolor pencils and a ruler. Marshall's Oil Pencils, if you have them, will come in handy, as will an Agate gold burnisher.

Because this painting should be set in a mat under glass, there is no need to mount it.

STAGE 1

Sketching the Figure Use an egg shape as a basis for the head, placing the eyes one-third of the way down and the nose halfway between the mouth and the eyes. The female figure can be drawn by dividing it into seven parts the size of the head. Measure the dancer's head.

Continue to measure down to her feet; you will find that she is seven and a half heads tall.

Draw a line for the measurement of the head on layout paper. Repeat the measurement seven and a half times, drawing a line at each measurement. Draw the body between these lines. The raised hand is one and a quarter times the head measurement. If you measure as you go, you should be able to make a good drawing in outline. The squares of the layout paper will help you in this and in getting the drawing in proportion.

Finally, trace your completed drawing onto matte acetate.

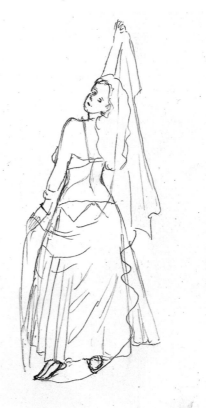

If you wish, you can trace the figure from the reference photograph. Do her outline, and mark points for eyes, nose, and mouth. Then sketch freehand as much as you can.

Drawing the Setting On a piece of layout paper, draw your frame. Use burnt umber watercolor pencil to draw the pillars. Put in a horizontal line across the bottoms of the pillars. Then lay the ruler from a center mark at the top of the frame to the corner of the frame on your left.

Draw a line from the horizontal line to each corner at the bottom.

Also mark the bottom of the frame at the center. Mark off three squares along the bottom of the frame, moving left from the center mark, then do the same moving to the right. Follow the diagram to fill in the tiles. Keep your

ruler on the point at the top center as you mark the intervals along the bottom line. Leave a space for the dancer as you put in the tile lines.

Fit the dancer into the setting by transferring both onto your ivorine. Use watercolor pencil in yellow ochre or pale gray.

Diagram for the setting of the painting.

The sketch transferred to ivorine.

STAGE 2

Applying the Gold Leaf Powder the ivorine with talcum powder and, using the gold adhesive, paint in the skirt and the brassiere. Put the adhesive on thinly and distribute it evenly over the skirt. Let it dry until slightly tacky, about an hour.

Have ready your sheet of tissue, to which the gold leaf is attached. Have a fine blade dusted in the talcum powder. Powder your hands.

When the size is ready, puff on it with your breath and lay the tissue over the skirt. Put down a smaller piece of tissue to cover the top of her costume. With a mop, tap over the tissue to help the gold adhere. Go *very gently*; otherwise, the gold beneath will show cracks.

Allow two hours for the gold to dry thoroughly. Then, holding the painting over a small container of water, gently brush with your mop to remove the surplus gold.

Overpainting the Gold With oil phthalo green, phthalo blue, and interference blue, twirl a brush in "recipe" and in the colors. Pull down folds from the waist to the bottom of the skirt. Then use the mop lightly across each fold. You will see that the interference color blends in with the other colors. This creates a subtle now-you-see-it, now-you-don't effect.

Using the transfer tissue to apply the gold leaf.

Removing the excess gold.

Deepen the color on the right-hand side of the skirt by using less "recipe." With your #000 brush and a dip in Grumbacher Medium 1, go all over the skirt, lifting off tiny swirls. This allows the gold to show through a pattern. You can follow a lace pattern, if you like, for more formal look, or any design you like. Make the pattern sharper where the folds billow out and catch the light.

The skirt must be allowed to dry overnight. Repeat the application of paint and the lift-off process for the top of the costume. Then let the painting dry until the next day.

Although the skirt is covered in paint, a shimmer of gold will show through, even where you have not lifted off.

STAGE 3

Mix interference lilac with dioxazine purple and dilute this mixture with "recipe." Glaze thinly over the skirt, including the lift-off. Some of the gold from underneath will still shimmer through.

When the glaze is tacky, point the #000 brush in oil titanium white mixed with the alkyd titanium white. Go over the design on the sides of the skirt, painting in a few of the patterns you put in as highlights. The lilac will tint the white.

The drying time is slowed by the use of oils, so you should leave the painting for a minimum of two days, and three if possible. Then, with the shell gold diluted with distilled water, put in a border of tiny gold dots around the bottom edge of the dress.

Glaze the dancer's top with the glazes you put on the skirt, then lift off. Use some tiny touches of interference blue and cobalt blue, and interference lilac and phthalo blue.

For the strings of pearls on the skirt, paint dots of alkyd titanium white mixed with pearlescent shimmer.

Twirl the brush in cobalt blue, then cobalt violet, and then interference lilac and paint tiny spangles along the waist in side-by-side strokes.

In some places I have mixed a little phthalo blue into the white of the skirt highlights, in other places cobalt blue, making a variation of patterns all over the skirt.

Mix some phthalocyanine green with "recipe" to help the oil to dry. Glaze over the dress with this, starting below the pearls. It should especially show in the folds below the veil.

Skin and Hair Mix oil burnt sienna and alkyd light red oxide and dilute with "recipe." Glaze over the dancer's skin with a delicate, thin layer of color. Touch lightly with the mini-mop.

As the illustrations on pages 130 and 131 show, at this stage you begin the preliminary work on the face (picture at right) and the hair. First, with alkyd burnt umber, underpaint the hair. Ignore the veil; paint the hair as it comes down her back in light strokes of color.

Brush the hair away from the forehead with the brush tipped in burnt umber. Press in a wavy motion. At the back of the head, raise the brush back to its point in one movement, and twirl it to a curl. Repeat this several times, as you paint the hair. Then with the brush dipped in "recipe," begin lifting off.

Burnishing the Skirt The glaze on the skirt should now be dry. Use the shell gold to go over the skirt, and pick out tiny details of the pattern, particularly on the areas where the veil will not reach. The gold should shimmer through the veil, so place enough here and there to show through.

Wait for about half an hour. Then, using silk, rub over the skirt, burnishing the shell gold. If no color comes off on the silk, lay a piece of glassine paper over the skirt and rub over it with a gold burnisher. If you do not have a burnisher, burnish a little more with the silk.

With Payne's gray and burnt umber, paint her eyes with a dark line all around them—standard makeup for a belly dancer.

Paint the eyebrows carefully in little strokes using burnt umber.

Paint a tiny curve for the edge of her ear.

For the nose, paint a faint line from her left eyebrow. Put in a tiny point for the nostril.

Paint in a tiny line to form the slight fold under the eye.

With light red oxide, draw a little line for her mouth.

In placing the ear respective to the line of the eyes, be careful to maintain the tilt of the head.

STAGE 4

The Face Mix alkyd light red oxide with oil titanium white and glaze over the face. Take some of this light color up the left of the arm and over the shoulder and stroke it back toward the shadowed side of her arm with the mop. Put a touch of oil burnt sienna on the tip of the brush, then another of light red oxide. Tap your towel to mix the colors slightly, and add a few dots of this color just below the lips and also to the cheeks. Put in a curved area of color under the eyes and continue back to the ears. Use a detail mop to blend the color.

The nose should be highlighted with tiny dots of titanium white.

Using your #000 brush put in her eyes with a mixture of burnt umber and brown madder.

Paint a highlight of light red oxide and titanium white on her right cheek. A tiny line of light comes down her nose with the same color.

Add a tiny slanting stroke of burnt umber for the nostril.

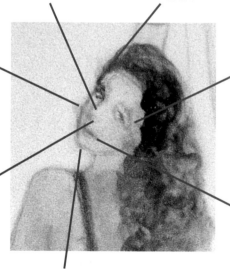

With burnt umber added to the light red oxide, tap in a shadow between the eye and ear.

Deepen the light red oxide of the mouth.

On the chin, add light red oxide and titanium white on the left side and stroke it to the bottom.

This is a good time to dilute cobalt violet with "recipe" and glaze in the veil over the dress. Do not bring it up to the arm yet. Then leave the painting to dry overnight.

The Setting Begin your next session by mixing some Naples yellow with alkyd titanium white, and with your #3 brush paint the curved wall behind the figure. Paint around, not over, her raised arm. Swirl the mini-mop to give it a misty light, especially at the left. Touch up the area under her chin and over her shoulder with a small brush, then blend into the larger area.

Paint a fine line of color for the bright edge of the left pillar, and go across the floor at the entrance, between the outside tiles and the inside tiles. Paint in the same color across the strip of lighted tiles where the figure is standing.

With alkyd burnt sienna and medium (not "recipe"), underpaint each pillar.

Use alkyd burnt umber, with Naples yellow on the tip of the angle brush, and stipple the inside of the two pillars. Blend, then stipple with the brush cleaned in mineral spirits. Tap with the mop again. For an even richer look, touch in a mixture of raw sienna, burnt umber, and white.

Go over the bright edge of the pillars again with the color used for

the ceiling; this will bring a warm light to the pillars.

This is also a good way to paint the bottom of the far wall, which is grainy and broken up in places. Glaze the top of the wall, which has been painted in Naples yellow and white, again, this time with a touch of vermilion and white.

Use a mop to give a soft stipple effect.

For the ceiling, mix oil raw sienna and alkyd Naples yellow and white.

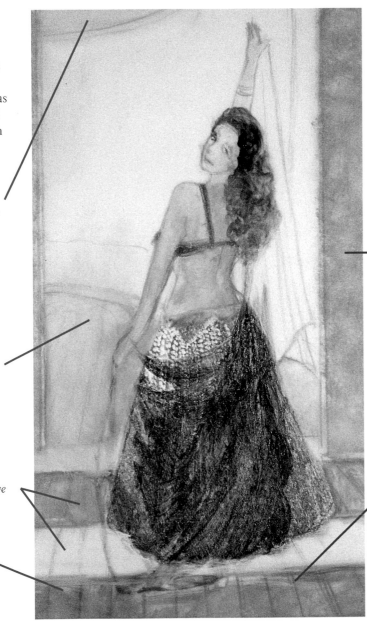

The pillars can be stippled again and again with various colors, then blended, for a rich, marble-textured look.

Glaze a thin layer of light red oxide over the curved path outside.

Paint burnt sienna across the tiles. Do not use much medium so you won't remove the tile lines drawn in watercolor pencil.

Add alkyd Van Dyke brown to the tile color and paint in the lines for the foreground tiles.

With translucent brown oxide and light red oxide and a touch of "recipe," paint the foreground tiles.

STAGE 5

Adding Color Once the painting is dry, further glazing and deepening of the color—putting in some shadows—can be done in the following steps:

1. Mix alkyd light red oxide with oil brown madder and glaze over the tiles in the front again.

2. Paint in the darker tiles with oil brown madder and alkyd burnt umber on the left of the picture. As you move to your right the tiles get lighter, so add some white to the color. Between the tiles paint a mixture of alkyd cobalt blue, oil brown madder, and oil titanium white—a lilac gray. Take this same color into the background path over the lines of the tiles. This must be allowed to dry.

3. With oil brown madder and alkyd titanium white, glaze the path. With the mop, swirl around at the end of the path. This will give a light effect there.

4. The same gray can be used to give highlights to the lines between the tiles, and for the lines on each side of the figure.

5. The skirt shades part of the tiles. Place a little reflection of violet just under the skirt over the tiles and part of the bright strip. Use a thin dilution of dioxazine purple with Payne's gray and "recipe."

6. With burnt sienna mixed with a little alkyd burnt umber, glaze over the shadowed areas of her back. Continue the color up and into the hair.

7. Also glaze over the shoulders and down the inside of the left arm.

8. Twirl the brush in "recipe" and then in burnt umber and paint in the slightly deeper shadow on the inside of her left wrist.

9. With the mixture of burnt sienna and burnt umber, paint the line of her spine from the back strap down. Blend. Then lift off a highlight down the right edge of the spine.

10. Sharpen the curve of her waist on the right with some burnt umber, taking it down to the hipline.

11. Paint the edge of her raised arm, excluding the bracelet, with burnt umber mixed with light red oxide.

12. Finally, when the paint has dried, paint a *very thin* dilution of oil burnt sienna over all the face, body, and limbs.

Alexandra's foot needs a little line of titanium white mixed with light red oxide on the side where it catches the light. Darken the sole of the foot with burnt umber and burnt sienna. Also use this color to hint at the right foot which can just be seen under the veil.

Adding Detail Paint the fingers of the upraised hand as if there were no veil attached to the first finger. Use your #000 brush dipped in "recipe" and in burnt sienna with a little burnt umber. Paint the fingers in one tiny stroke. Then carefully lift off the paint from the center of each finger. This will push some of the paint to each side of the finger. Leave the fingers to dry.

To paint the fingers of the left hand, put in burnt umber and lift out the fingers. This should push a tiny line between each finger. (The thumb is hidden.) This hand must be allowed to dry; then it can be glazed over with light red oxide and titanium white. The lines will show through, but the edges of the fingers will not look "painted on."

Now, before doing the veil, deepen the hair with a mixture of burnt umber and burnt sienna, and add lights to the hair with a touch of yellow ochre and titanium white pulled through the wet glaze with the very tip of the brush. Tap gently with the mop.

STAGE 6

The Veil Dip your #1 brush first in oil cobalt blue, then in cobalt violet. Put the point down just at the finger, press, and pull straight down, going over the veiling you put in earlier. Repeat, perhaps reversing the order of the colors, tipping the brush to violet first, then blue. The colors in the folds will then vary. Copy the folds as you see them in the reference photo, doing the larger folds and then the smaller ones. Add a little oil titanium white to the veil color for the light areas, and with the detail mop and a small sable pull it into the wet color.

If your color does not become translucent enough, add a touch of linseed oil instead of "recipe" to the white. But remember, linseed oil will delay drying time considerably.

The lower hand holding the veil should be dry. Glaze over it with your diluted blue and violet and pull the glaze up in a curve over the previous one. Let it disappear into the edge of the downward folds. A touch of Payne's gray mixed with phthalo blue and "recipe" will give you shadows in the folds. Also glaze over the bracelets and the brassiere with the blue-violet, to which you could add interference blue. Then let the picture dry for one or two days.

The veil must be put in with the thinnest of glazes, and not gone over too often, or you may lose transparency. Indeed, you should lift off color here and there.

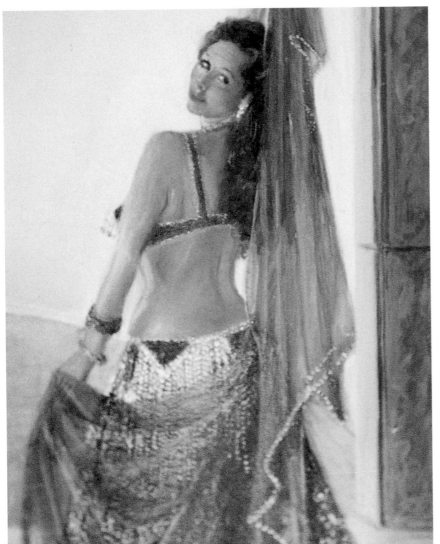

If some gold leaf does lift off, add some little patterns in shell gold here and there. The veil can be glazed in again over these areas when the first glaze is dry.

135

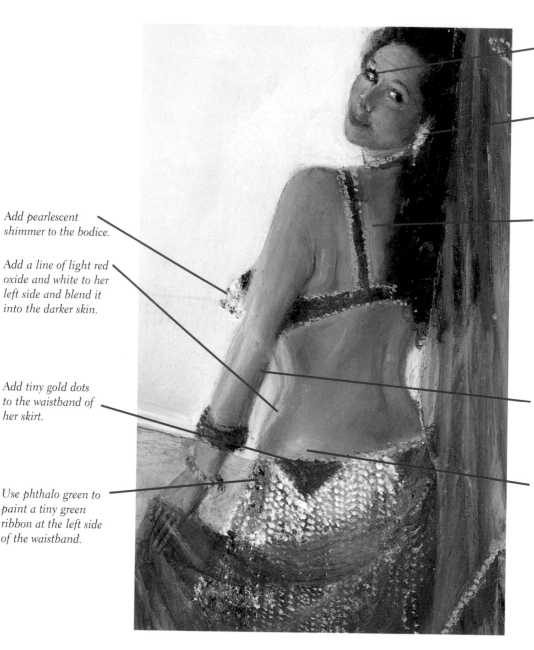

A *pinpoint of white can be added to each eye in the left corner.*

Add a pinpoint of shimmer to the earrings.

Add a line of light red oxide and white to the shoulder blade.

Add pearlescent shimmer to the bodice.

Add a line of light red oxide and white to her left side and blend it into the darker skin.

Add tiny gold dots to the waistband of her skirt.

Brush in burnt umber for the shadow from her left arm.

Use phthalo green to paint a tiny green ribbon at the left side of the waistband.

A touch of white will highlight the hip.

STAGE 7

Finishing Touches Next, with shell gold, add minuscule dots all down the edge of the veil. Add a gold bracelet in tiny dots on her left arm and put in the earrings. Make gold sequins on the straps of her costume—as minute as you possibly can.

Check over the whole figure, and add soft shadows of burnt umber where needed. Possibly the left arm could do with some darkening on the edge. Whenever you put the shadow in, tap gently with the mop.

Have patience painting the face. I worked on the nose for three hours; the mouth took several tries. Whenever you get even a part of the mouth correctly, leave it so that it can dry.

In the setting, use oil titanium white mixed with alkyd Naples yellow and a touch of vermilion for a thin glaze over the brighter tiles. Next paint the darker tiles again individually, using brown madder and burnt sienna. Add a little white to the light red oxide and put some of this color here and there just on the left of the foreground tiles.

When the tiles are completely dry, glaze in shadow color of cobalt blue, Payne's gray, and burnt umber from the pillar on the left. Another shadow goes from the bottom of the veil to the right.

When you are completely done, let the picture dry and do not be tempted to go back to it. The picture may be varnished, but since it is to be framed behind glass, this is not necessary. If you do decide to varnish, use Schmincke wax varnish, but you should wait at least six months, and preferably a year, before doing this.

ALEXANDRA

In the finished picture, shown here actual size, the shimmering brocade and gold touches will not be noticeable immediately, unless put under a bright light.

A FINAL WORD

Miniature painting began as a practicality, an art form used in the Middle Ages as a passport or I.D. photograph would be used today. As we have learned, it evolved into a separate artistic discipline with a number of features that distinguish it from other disciplines. It is important always to keep these distinctions in mind.

First of all, the miniature is distinguished by its painting technique, which is the application of many thin glazes of color. These glazes capture light and create a luminous beauty essential to the miniature's "look."

The exercises in this book have shown in myriad ways that the miniator's brushwork utilizes dots, thin lines, hatchings, and stippling, and excludes the kinds of raised brushmarks and impastos that are the hallmarks of many artists' styles in other genres. A miniature painter does not include raised brushstrokes in his or her painting vocabulary but aims for the smoothest surface possible, so that nothing detracts from the detail. Even in a landscape full of tiny dots that render foliage, there should be no raised points of paint, even if oils were used.

Fine, realistic detail and three-dimensional subject matter are also features of defining importance to the discipline. Accordingly, a tool like the palette knife, which is responsible for some of the most beautiful effects in other painterly disciplines—particularly abstract ones—has no application in miniature work. It is suitable for producing broad patches that emphasize the surface of the work. Likewise, a collage, no matter how artfully small and pleasing, would not qualify as a miniature.

By the same token, canvas is seldom used as a ground in miniature painting; the size of the weave is out of proportion to the miniature, which is normally less than 5 x 7" in size. Thus the characteristics of much great easel painting by impressionists, cubists, expressionists, and the like are not shared by the art of the miniature, in which much effort has been concentrated upon making the subject fully identifable. An easel painting is said to be tightly rendered if it is crisply detailed. A miniature is necessarily tightly rendered; and this distinction always applies.

A similar sharp contrast is evident between miniature painting and watercolor painting, which is distinguished by the technique of painting wet-into-wet. The content becomes hazy and loose by this method, and thus has no real application in the creation of a miniature.

In a miniature, composition and color balance are exceptionally important. Drawing must be as accurate as possible. In portraiture, a skillful use of light and shadow, factors in capturing three-dimensionality, enhance the realism as much as the exact detailing of the eyes and hair. As we have seen, ornamentation of the portrait with precious stones and pearlescent colors is a special tradition within the discipline.

"Miniature," then, will always mean much more than "small," where the delicate art of miniature painting is concerned. Keep these distinguishing features in mind as you go to work, and you will be working as part of a well-defined and enduring artistic tradition.

APPENDIX

List of Suppliers

For ivorine, vellum, gold frames with curved glass, Joan Willies books, and all other materials used in this book:

Miniature Painting, Etc.
13805 Nice Lane
Odessa, FL 33556
Phone (813) 920-4147

For Winsor & Newton products:

ColArt Americas, Inc.
11 Constitution Ave.
Piscataway, NJ 08855-1396
Phone (908) 562-0940

For retarder medium (Liquitex Slow Drying Medium #12-6701):

Binney & Smith, Inc.
1100 Church Lane
Box 431
Easton, PA 18044-0431
Phone (800) 272-9652

For Silver Brush Products:

Silver Brush, Ltd.
5 Oxford Court
Princeton Junction, NJ 08550-1810

For Rotring Transparent Acrylics:

Koh-I-Noor, Inc.
100 North Street
P.O. Box 68
Bloomsbury, NJ 08804-0068
Phone 1 (800) 877-3165

For Robert Simmons and Daler-Rowney colors:

Daler-Rowney
2 Corporate Drive
Cranbury, NJ 08512-9584
Phone (609) 655-5252

For calligraphers' supplies, shell gold, gold leaf, burnishers, glassine, etc.:

The Calligraphy Shoppe
P.O. Box 715
Safety Harbor, FL 34695

For interference colors in watercolor, acrylic, and oils:

Daniel Smith
4150 First Avenue S.
P.O. Box 84268
Seattle, WA 98124-5568
Phone 1 (800) 238-4065

For silver point and gold point:

T. B. Hagstoz & Sons, Inc.
709 Sansom Street
Philadelphia, PA 19106
Phone 1 (800) 922-1006

For gold adhesive and gold size:

Houston Art & Frame
P.O. Box 56146
Houston, TX 77256
Phone (713) 868-2505

For Marshall's Oil Pencils:

The Brandess-Kalt-Aetna Group, Inc.
5441 N. Kedzie Avenue
Chicago, IL 60625
Phone (312) 588-8601

For Krylon acrylic resin spray:

Sherwin Williams Specialty Division
Customer Service
31500 Solon Road
Solon, OH 44139

For fine, detailed reproductions of miniatures, which are desirable in promoting your work:

CMC, Inc.
1001 Pearce Drive #201
Clearwater, FL 34624-1103
Phone (813) 797-4272
Fax (813) 797-2724

For Joan Willies videos:

Stampa & Willies
P.O. Box 7659
Clearwater, FL 34618

International Miniature Art Societies

UNITED STATES

Georgia Miniature Art Society, Inc.
(GMAS)
c/o Jill Pickenpaugh
2401 Renney Court,
Marietta, GA 30066

Miniature Artists of America (MAA)
c/o Kay Petryszak
1595 N. Peaceful Lane
Clearwater, FL 34616

Miniature Art Society of Florida, Inc.
(MASF)
President, Denver Boyers
534 Baywood Drive
South Dunedin, FL 34698

Miniature Painters, Sculptors and
Gravers Society of Washington D.C.
(MPSG)
c/o John A. Thompson
1917B Biltmore St., N.W.
Washington, DC 20009

Montana Miniature Art Society, Inc.
(MMAS)
c/o Jack Akerstrom
2422 Brentwood Lane
Billings, MT 59102

Wyoming Miniature Art Society (WMAS)
1040 West 15th Street
Casper, WY 82604

Associations

Glynn Art Association
536 Ocean Boulevard (In the Village)
St. Simon's Island, GA 31522
*Holds an annual juried competition and
exhibit of miniatures.*

Laramie Art Guild
P.O. Box 874
Laramie, WY 82070
*Holds an annual juried competition,
usually in December.*

AUSTRALIA

Australian Society of Miniature Art (New
South Wales), Inc. (ASMA)
c/o Patricia Moy
12 Ann Street
Willoughby, Sydney 2068

Australian Society of Miniature Art
(Queensland), Inc. (ASMA)
c/o Lyn Lubach
P.O. Box 443
Beaudesert, Queensland 4285

Australian Society of Miniature Art
(Tasmania), Inc. (ASMA)
c/o Bernadette Connor
The Hibiscus Gallery
5 Ashfield Street
Sandy Bay, Tasmania 1005

Australian Society of Miniature Art
(Victoria), Inc. (ASMA)
c/o Noela Patane
17 Heacham Road
Eltham, Victoria 3095

BANGLADESH

Miniature Art Society of Bangladesh
(MASB)
c/o Khalid Mahmood Mithu
G.P.O. Box 5061
New Market, Dhaka 1205

ENGLAND

The Royal Society of Miniature Painters,
Sculptors and Gravers (RMS)
Ms. S. Burton, Secretary
Burwood House
15 Union Street
Wells, Somerset BA5 2PU.

The Hilliard Society (HS)
Ms. S. Burton, President
(address above)

The Society of Limners
Colleen Melmore, Executive Secretary
104 Poverest Road
Orpington, Kent BR5 2DQ

The Society of Miniaturists
41 Lester Street
Riverside Gardens
Ilkley, Yorkshire

FRANCE

Société des Artistes en Miniatures et Art
Precieux (SAMAP)
c/o Anne Luquet de St. Germain
20 Rue Guersant
Paris 75017

SOUTH AFRICA

Miniature Art Society of South Africa
(MASSA)
c/o Charmian Kennealy
Rothlands #4
31 Rothesay Avenue
Craighall Park
Johannesburg 2196

Index

MISS HAYLEY MILLS

This portrait, shown actual size, was painted
in oils and alkyds on ivorine. For the necklace
I used 23-karat gold and crushed pearl.
Courtesy of Miss Hayley Mills.